BANGWA FUNERARY SCULPTURE

ART AND SOCIETY SERIES
Edited by Peter J. Ucko

BANGWA
FUNERARY SCULPTURE

Robert Brain and
Adam Pollock

UNIVERSITY OF TORONTO PRESS

First published in North America
by University of Toronto Press
Toronto and Buffalo

Printed in Great Britain

ISBN 0-8020-1789-4
Microfiche ISBN 0-8020-0104-1
LC 77-163804

CONTENTS

LIST OF PLATES

LIST OF FIGURES

LIST OF COLOUR PLATES

DEDICATION

ambo beshua be ngwe
bo
Ya wo Kof

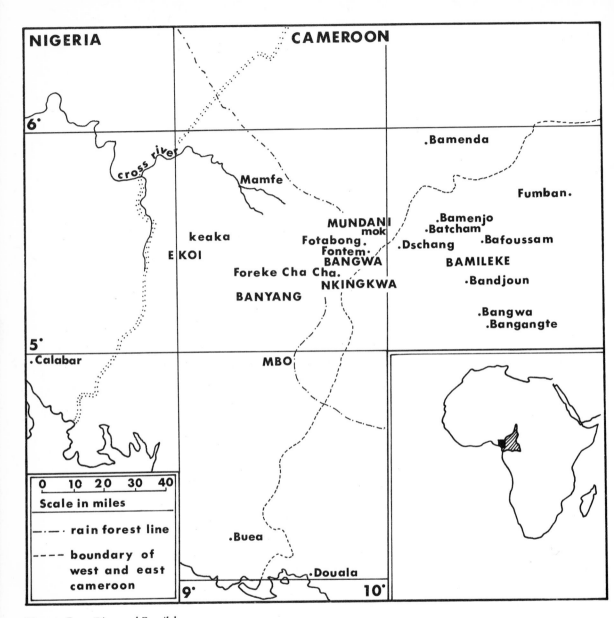

Figure 1 Cross River and Bamileke areas

Introduction

The first European penetrated the fastnesses of the Bangwa mountains in 1897. He was Gustav Conrau, a German colonial agent, seeking trading contacts and labour supplies for the southern plantations. He records[1] his impressions of the country with some enthusiasm: the romantic mountain scenery with its narrow cliff paths and wild waterfalls; the imposing lines of the tall Bangwa houses; the quiet dignity of the chiefs and the deceptive subservience of their wives. To celebrate the arrival of their first white man ('their huge red baby') dances and ceremonies were performed during which the Bangwa men changed their simple bark-cloth loincloths for extravagant clothes and splendid masks. Conrau admired the works of art which appeared during the dances. At Fontem, the chief presented him with a splendid brass pipe. He later acquired, through sale or gift, a collection of masks and statues which were sent down to the coast with the plantation labourers and then to Germany and its museums. Two years later Conrau was dead, killed either by the Bangwa or by his own hand. In the reprisals that followed, the palaces of the chief and many of his subchiefs were razed to the ground. Many carved houseposts and ritual objects stored in retainers' houses at the palace entrances were destroyed in the process.

The Germans maintained a military and trading station in Fontem until they were defeated by British soldiery in 1915. Thenceforth, until independence in 1961, the Bangwa remained a somewhat isolated outpost of the British Empire, four or five days' trek away from divisional headquarters at Mamfe,

1

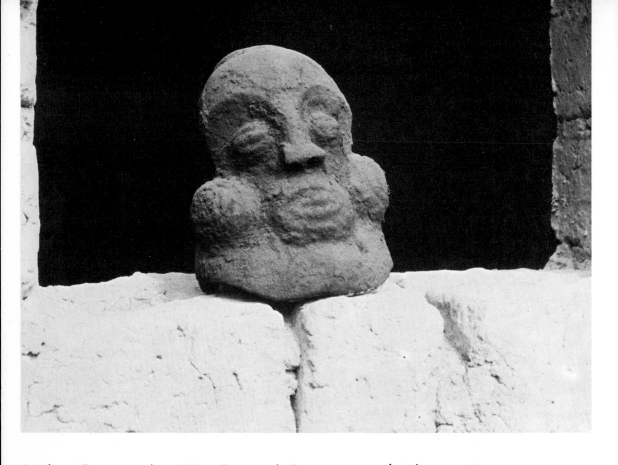

Southern Cameroons (now West Cameroon). In 1965 a general anthropo-
logical study was made of the Bangwa, during which it became clear that
Fontem was an important artistic centre. Sculptors were found to be still at work
providing masks and figures for dance and cult associations. Important pieces
were kept by the chiefs and other nobles in the interior of their compounds,
sometimes on display, sometimes hidden inside smoky hut-lofts (Plate 1) or
skull-houses. In 1965 a summary study, with photographs, was made of the role
of art in Bangwa society. Until now the pieces marked 'Bangwa' in German
museums and private collections had been attributed to an eastern Bamileke
chiefdom also called Bangwa (see map on p. x), which had been included in a
survey of Bamileke art by Lecoq[2]. But when the expedition returned to Europe
in 1966 many of the splendid ancestor memorials (Plate 2) and portrait figures
in museums were seen to be very similar to those which had just been observed
in the field. Closer study confirmed the similarity. Details in museum catalogues[3]
showed that many of the figures and masks were in fact from Fontem, Fotabong
and Foreke Cha Cha, three southern chiefdoms of the West Cameroon,
Bangwa group. Most of these objects had been sent back to Germany by

Plate 1
Typical Night mask

2

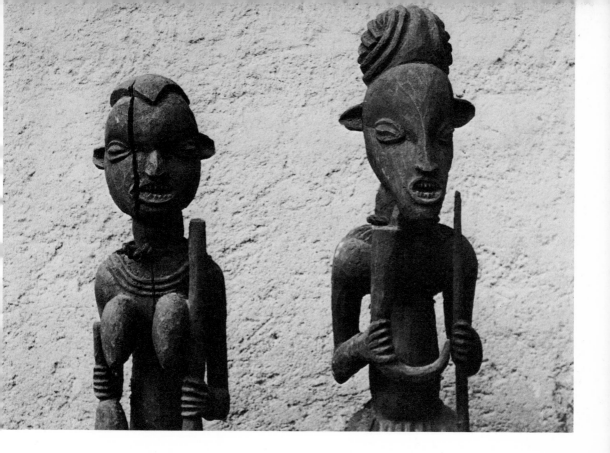

Plate 2
Ancestor memorials

Conrau. Fortunately he had included some meagre ethnographic notes about them and the names that the Bangwa had given them. These provide a check as to their provenance.[4]

In 1967 both authors visited Bangwa for six months. They now had a better idea of the significance of Bangwa art, and planned to make a thorough study of the sculptures in their social context.

This book is concerned with those objects of Bangwa art which make their appearance during the elaborate ceremonies following the death of an adult male or female. These ceremonies, known in pidgin English as a 'cry-die' or a 'cry', provide opportunities for the innumerable dance societies and cult associations to which Bangwa men and women belong. After a summary account of Bangwa culture, the bulk of the book is devoted to a description of a cry performed at the death of a paramount Bangwa chief. A final chapter gives a description, in more detail, of some of the more important groups of sculpture associated with typically Bangwa cult associations. For convenience the commonly used pidgin term for dance society or cult association – 'juju' – will be used. The Bangwa also apply this word to art objects, which have any ritual

significance. The Bangwa term, although more exact, would have less imme-
diate meaning to an English reader.

The account of the cry given in Chapter Four is an ideal one. The death,
anointing and burial of an important Bangwa subchief were witnessed; these
rites are similar to those carried out for a paramount chief. The elaborate and
secret rites surrounding the installation of the chief of Foreke Cha Cha were
also seen. During the dry season in Bangwa a cry may be held every week to
celebrate the death of a person who has died during the long rainy season (Col.
pl. 11). In Bafou-Fondong near Dschang an extremely splendid cry was held
during this time, celebrating the death of the chief who had been killed by
terrorists. But for the most part the model for the account given here was the
death, and the ceremonies which followed it, of Chief Fontem, c. 1885–1951
(Plate 3), and the account is based on detailed and corroborative descriptions of
the event given by participants in the rites, particularly by the present chief. The
performance of the societies or jujus, of course, have all been witnessed by the
authors on innumerable occasions.

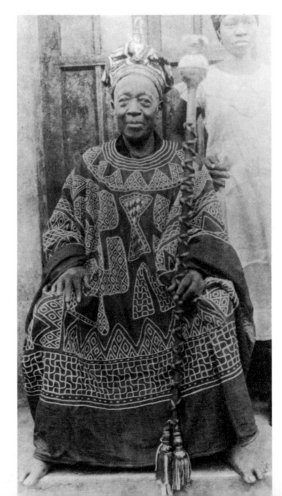

Plate 3
Assunganyi, Chief of
Fontem (1885–1951)

4

CHAPTER ONE

Bangwa society and culture

The Bangwa comprise nine independent chiefdoms of which Fontem is the largest, with a population in 1953, of 7,400. The others, from north to south, are Fozimogndi, Fozimombin (both together, 4,047), Fossungo (767), Fonju, metor (2,432), Fotabong I (1,909), Foto Dungatet (1,546), Foreke Cha Cha and Fotabong III (together, 1,462). These names are the ones in common use and are really the chiefs' titles. 'Fontem' nowadays is the name given indiscrimi, nately to the chief, his capital and his country, though strictly the country is called Lebang, and the capital where the palace and market are situated, Azi. In the authors' field-work the chiefdoms covered most thoroughly during the recording of works of art were Fontem, Fotabong and Foreke Cha Cha. These are in fact, now as in the past, the centres of sculpture, and there seems to be very little carving activity in the northern chiefdoms.

The name 'Bangwa' conveniently describes all the inhabitants of the nine chiefdoms, though the Bangwa do not, in any sense, constitute a unified tribe. The word derives from the stem *Nwe* (or *Nwa* in the northern dialects) which refers to both the country and the language. 'Bangwa' is correctly written *MbaNwẽ* (cf. *MbaNwa* for the easterly Bamileke chiefdom). It is doubtful whether all the inhabitants of the nine independent chiefdoms ever thought of themselves as 'we, the Bangwa' before they were grouped together as a unit of local government by the British colonial administration in 1921. Moreover, the term *Nwẽ* is used more specifically by Banyang and Bamileke neighbours to

5

describe the central highland areas of the four chiefdoms Fontem, Fotabong, Fonjumetor and Foto Dungatet. Another term, Mok, describes the country of the northernmost chiefdoms Fozimogndi and Fozimombin, which are linked geographically and historically with other Mok chiefdoms among the Bamileke. Each Bangwa chiefdom maintains much closer cultural and commercial links with its Bamileke neighbours to the east than with its Bangwa neighbours to the north and south. Trade routes connecting the grassfields and the forest pass through a single chiefdom towards the savannah markets.

The Bangwa language is closely related to languages spoken by the Bamileke of East Cameroon, particularly round Dschang and Fondongela. There are important differences in dialect even among the Bangwa themselves. On the whole the degree of mutual understanding depends on proximity; the inhabitants of Fontem have little difficulty in understanding their immediate Bamileke and Bangwa neighbours with whom they have the closest cultural links. Greater differences occur between the southern Bangwa chiefdoms and the northern Mok chiefdoms (see map on p. x), which are cut off by the nature of the terrain. Nevertheless it appears that *Nwẽ* is related to other Bamileke languages, even as far as Fumban, through a chain of mutual intelligibility. These linguistic links reflect cultural links, particularly the interconnection of art substyles in the general Bamileke culture area. The languages of western and southern neighbours, Mbo and Banyang, are distinct, though there is a considerable amount of word-borrowing, especially between the Banyang and the Bangwa. Banyang is spoken by traders and members of the popular secret societies (the Leopard society, for example) which are imported via the Banyang from the Cross River area. Nearly all Bangwa, men and women alike, speak pidgin English.

Until the middle 1960s communication with the outside world was on foot, and it was an arduous two-day trek from the road terminus in Banyang to Fontem. The path crossed the vast Banyang forests, passing through villages strung out on either side of a sandy street and traversing fast-flowing tributaries of the Cross River by means of woven swing-bridges. The Bangwa chiefdoms are situated far from the heat of the forests. Most of the Bangwa inhabit the middle regions (between 3,000 and 4,000 feet up), where the sparseness of oil-palm groves indicates the beginning of a highland climate. Compounds are scattered all over these escarpments. The highest inhabited point is about 7,000 feet, the lowest about 1,500 feet. From their vantage point in the mountains the Bangwa can look across the misty forests of the Banyang, Keaka and Ekoi to the Cross River lands of Biafra. In the other direction the undulating plateau 'grassfields' of the Bamileke stretch north-eastwards towards the great chiefdoms of Bandjoun and Bangangte and the kingdom of Fumban. Direct routes link Bangwa

to these areas; with the Bamenda peoples to the north the mountains prevent such easy contact.

THEIR NEIGHBOURS

Mainly for commercial reasons the Bangwa have maintained contacts with their neighbours on all sides: the Bamileke to the east, the Mundani to the north-west, the Banyang to the west and the Mbo and Nkingkwa to the south.

The Mundani, who claim to be migrants to their present position in the mountains, are very different in language, social organisation and material culture from the Bangwa, though they have adopted elements of Bangwa political organisation, such as titles, chiefship and secret societies. Today the Bangwa and Mundani share a council and a treasury but the two peoples lack basic common interests and there is a good deal of mutual suspicion between them.

With the Banyang, the Bangwa have always had vital trading links. In Ban-yang markets, the Bangwa bought, or exchanged for slaves, such necessities and luxuries as salt, guns, cloth, currency beads and other miscellaneous European goods. Legend recalls that the son and heir of Chief Fontem was captured and enslaved by the Banyang, and was only released through the intervention of a Banyang chief, to whom a payment of seven slaves was made. In the present century, however, the Bangwa have become independent of Banyang markets, and they trade direct to Mamfe and Calabar for European goods. The Banyang still offer interesting bargains in the form of effective anti-witchcraft medicines. They are also responsible for the colourful and presti-gious recreational societies which are so conspicuous at Bangwa cries.

Any account of Bangwa social organisation and culture, however, is pri-marily an account of a Bamileke culture. The term 'Bamileke' is an administra-tive one, and was used first by the Germans, to describe a very mixed grouping of independent chiefdoms, almost a hundred of them, scattered over a vast, fertile plateau centring on Bandjoun, Bafoussam, Bangangte and Dschang. The Bamileke today number over half a million. Their social organisation has been described by Tardits[1] and Hurault.[2] Each small State is ruled by a sacred chief to whom his subjects owe political allegiance and economic services and to whom they are bound by proliferating ties of kinship and clientage. They worship matrilineal and patrilineal ancestors, through male and female skull lines. The Bangwa are the westernmost Bamileke group and as a result are more influenced by forest patterns than the central plateau chiefdoms. The Bangwa are also the only Bamileke peoples to have been administered by the British after the defeat of the Germans during the First World War; East Cameroon came under French tutelage. Because of their isolated position in the

mountains their institutions have suffered less disturbance than those of their eastern neighbours.

The Mbo are their hereditary enemies. Wars originated from disputes over boundaries or oil-palm groves and the kidnapping of each other's nationals for sale or food. Like the Banyang, the Mbo also played an important part in the early dynastic history of Bangwa chiefdoms and related Bamileke chiefdoms in East Cameroon. Foreke Cha Cha has historical connections with Mbo; Fongo Tongo, Foto, Foreke Dschang all claim Mbo origin. Unfortunately, since there has been no thorough ethnographic study of the Mbo, the degree of cultural interconnection is not clear. The Nkingkwa inhabit the mountain area on the Mbo-Bamileke borders. Linguistically related to the Mbo, they inter-marry with the Bangwa and have adopted their institutions, such as chiefship. The Nkingkwa represent an important intermediary stage in a process of 'Bamileke-isation' which has been going on for centuries in this region. The process eventually leads to the loss of the people's original language and the wholesale adoption of savannah culture and values. This seems to have happened with the Bangwa; the majority of the dynasties of chiefs and subchiefs claim a forest origin, and yet in terms of culture, language and interest the people must be classified as Bamileke.

HISTORY

History and legend confirm this process of 'Bamileke-isation'. Paramount chiefs, who have the longest pedigrees, rarely trace their dynasties back further than seven or eight generations. Legend tells of the founding of the chiefdom by a hunter who came from the forest with his following – his family and the classic Nine servants whose descendants today form the inner sanctum of the secret Night society. The hunter met the Beketshe, a loosely grouped hunting and gathering people who lived a naked, nomadic existence in the wooded mountains without the advantage of permanent shelter or agriculture. The forest hunter, through guile or guns, deprived these people of their proprietary rights to the land. These Beketshe, from whom some contemporary Bangwa still claim descent, are described in stories as brainless, fickle and incredibly gullible, and are a constant source of amusement to sophisticated Bangwa. According to the myths the Beketshe were taught farming, fire-making and such elementary facts of life as copulation. The Beketshe ceased to rely on wild plants and game and the union of these armed hunters and mountain nomads formed the nucleus of the Bangwa people who were now confronted by the Bamileke peoples of the grasslands: settled agriculturists who fought with spears and who had a very elegant and highly structured political system. Guns again gave the forest hunter victory over these scattered miniature chiefdoms. A common

myth tells how he hoarded royal paraphernalia (leopard skins, ivory tusks, the carved figures), the possession of these symbols of royalty ranking him immediately and indisputably as their suzerain.

These legends clearly recount in mythical form the arrival in the mountains and savannah of people from the forest who had access to European goods, especially guns, and who through superior prowess and commercial ability overcame the original inhabitants of the mountains and migrants from the eastern savannah. They did not, however, impose their cultural background, but adopted to a man the language and customs of the eastern culture we now know as Bamileke.

Written records begin with the arrival of the Germans. The Bangwa in Fontem fought with Germans after the murder or suicide of Conrau in 1902. But their antique Dane-guns and spears could have little effect against modern guns and trained soldiers. Some Bangwa remember the Germans today: the 'factory' and the cloths and pans they could buy in exchange for oil, wild rubber, ivory, etc. Many remember the harsh treatment they received at the hands of the German-trained soldiers – as porters and labour recruits. After the defeat of the Germans in 1915 the British remained in effective control of the Bangwa area until independence in 1961. Bangwa was cut off from Bamileke neighbours and aligned with the Banyang, Mundani and Mbo. The British established no administrative post and apart from occasional tours by district officers and medical officers left the Bangwa to themselves. Customary courts were established to hear local civil cases; the members were the traditional chiefs. The administrators interfered only to settle land and boundary disputes and criminal cases, such as murder and witchcraft accusations.

The most prominent Bangwa chief in this period was Assunganyi (Plate 3), chief of Fontem. It was he who met Conrau when he arrived in Fontem in 1897. Later he organised the war against the Germans, and after defeat went into hiding in the forest for 'fourteen years', putting his son on the throne in his stead. When the deceit was discovered the Germans exiled Assunganyi to Garua in North Cameroon. He was reinstated by the British in 1915 and his inimitable personality dominated Bangwa politics until the 1950s. Assunganyi's influence is still to be seen in Bangwa. He favoured traditional customs, and few, even district officers, cared to run counter to his wishes. He ruled his country and his large compound (he had over a hundred wives) with a generous, if iron hand. His prodigality was proverbial; no feast can be held today without unfavourable comparison with the orgies of meat, yams and wine which Fontem Assunganyi provided for his people. He became a legend in his lifetime and tales are told today of his feats of strength, his cunning, his hunting, and his fighting and dancing prowess. He could flay a wife and stop in the

9

middle to listen to a bird's song. He made a show on every possible occasion; his German brass band played, his horses paraded, his wives danced and his Dane-guns exploded when he wished to impress a neighbouring chief or a visiting European. When the Bangwa become nostalgic and recall the 'good old days', they refer to the time when the old chief was alive, when Bangwa was prosperous, the women naked and obedient, the young men respectful and the crops plentiful. Assunganyi died in 1951 and was succeeded by his son, Defang, the present chief.

TRADITIONAL SOCIETY

The British colonial administration interfered as little as possible in Bangwa affairs. Consequently the Bangwa lagged behind their Bamileke neighbours in acquiring European technological benefits; and their transition from the pre-colonial to the modern world has been less violent and has been characterised by slower social change. But with independence, in 1961, things began to move fast. The first road was built. Missionary activity was intensified. Until 1966 there was very little proselytisation; now there is a hospital and schools and a permanent Catholic mission station. The face of the country is changing too. Villages are springing up round the important markets. Ordinary people are leaving their isolated homesteads to build European-style compounds near the roads, which link the Bangwa with the towns, hospitals and markets of East and West Cameroon. The Bangwa are adaptable to new and profitable situations. Within a generation or two their culture will change beyond recognition. In this chapter it is not the contemporary situation which is described, but the indigenous, distinctive and highly developed culture which is today disappearing. Many of these elements still flourish. Others, involving religious and political institutions, lack significance for most Bangwa.

The Bangwa have never lived in villages. Across the hills a complicated tracery of paths links the compounds of individual families. In front of the compound of a noble or wealthy commoner is an open dancing place, before the meeting-house where visitors, friends and relatives meet. Within, each wife has her house in which she cooks and works and her children sleep. The compound head has his own house hidden behind a tall fence of fern poles. Here he keeps his heirlooms and his ancestors' skulls and receives intimates.

The tall, solid houses are impressive to look at. Flat sites are difficult to find and areas are laboriously levelled by hand. The traditional shape of a Bangwa house is a cube on a shallow circular foundation of stones surmounted by a conical thatched roof (Plate 4). The size and proportions vary according to the importance of the building but the basic shape of a domestic hut and of a large meeting-house is the same. The method of making the walls recalls European

Plate 4
The Fontem meeting house

10

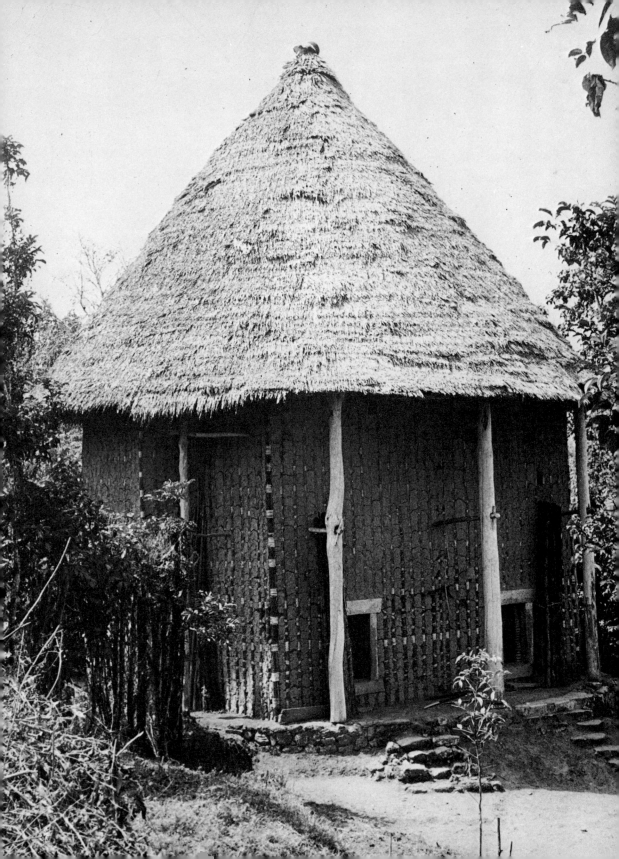

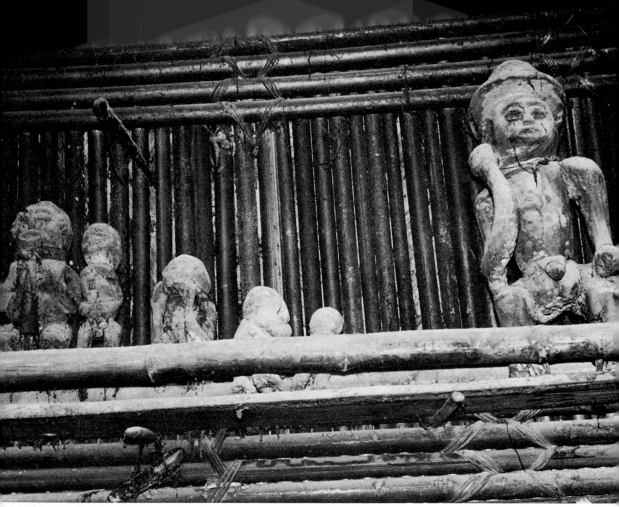

Plate 5 Bamboo lining of a house interior

half-timbering: a wooden framework of ant-resisting fern poles is plastered to leave the framework revealed. The roof is constructed of four triangular frames bound on to a round tray, the apexes of the triangles joining in the middle to form the curve of the roof (Plate 4). The interior of the house is either plastered or lined with bamboos tied together with vines making decorative patterns (Plate 5). Houseposts may be carved (Fig. 2).

Today houses are being made of mud-blocks. The vast meeting-houses are crumbling and being replaced by the ubiquitous concrete and iron-roofed buildings of contemporary Bamileke towns.

An elaborate etiquette gives evidence of a complicated ranking order which includes chiefs, subchiefs, nobles, commoners, royals, slaves, servants, titled servants; also the old and the young, men and women, wife-givers and wife-takers. The most obvious differentiation is between the sexes. Women are expected to adopt a subservient mien in the presence of men. They sit only when told to and do not eat when men are present. When a woman greets a noble on the farm paths she will bow, stamp her foot in greeting and move aside. Even today the old ladies of a compound will greet an important visitor by sweeping the ground with a swaying motion of the hands. Women, however, can achieve positions of importance. Titled wives and princesses take precedence over commoner men. Old women, particularly mothers of large families, receive great respect. General courtesy between the sexes and all ranks is a marked characteristic of Bangwa social life. The poorest woman, the meanest servant, the smallest child, is shown a serious and respectful attention due to any individual.

The Bangwa chief is the focal point and strength of the traditional system. He is not divine, but he has sacred attributes and performs important rites for the well-being and fertility of the land and people. In the past, as in some respects still, the chief was feared and with reason, since his power over his subjects was great. A paramount chief may be very rich. Ivory tusks and leopard skins are his due as traditional royal symbols. At the death of subchiefs and nobles he receives death dues. He owns extensive oil-palm plantations, which in the past were cared for by slaves and servants. There is no formal tribute system although conquered areas, such as the Mbo, formerly brought smoked fish and game. But the greatest source of wealth is women. A chief, today, may have up to fifty wives and important rights in the marriage payments of a large percentage of his female subjects. Fontem Assunganyi, who was frequently accused of cupidity, gained considerable wealth as a marriage broker, arranging the marriages of widows or disputed wives to the highest bidder. He also confiscated the property of witches and adulterers who were hanged or sold. More reputable gains are made today from fines and from 'thank-you' fees for settling disputes or administering a nobleman's property during the minority of his heir.

Although the chief is the supreme ruler important powers are delegated to subchiefs. Both within the subchiefdoms and attached directly to the palace of the chief are hamlets administered by nobles, either royal sons, commoners or ranking retainers. Some hamlets consist only of a man, his wives and children and a single servant.

Subchiefs have a good degree of political independence. They vary in origin:

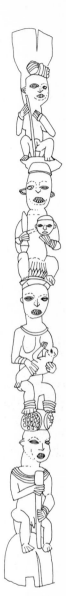

Figure 2
House-post

13

some are conquered, previously independent chiefs; others are royal cadets raised to subchief status. In the past an important subchief ruled a miniature state with its own hamlets, receiving the respect due to a chief, though subchiefs were forbidden to undertake private wars, or to inflict the death penalty in case of witchcraft, murder or adultery with a chief's wife. In the segmented political system, even the hamlet heads had important governing and judicial rights. Matters of national importance were settled at the paramount chief's palace by the subchiefs, hamlet heads and chief in concert. Leaders of the country also met at performances of the chief's Gong society (called *lefem* in Bangwa after the sacred copse where they met). Here they discussed affairs of common interest and informally demonstrated their loyalty to their chief.

Royal brother and sister titles are a feature of the Bangwa political system. A chief's property goes primarily to his heir, but an important part is divided among his children, who also receive titles. *Nkweta*, for example, is the chief's second-in-command. He may succeed if his brother dies soon after his installation. There are also two female titles, *ankweta* (female *nkweta*) and *mafwa* (female chief). *Mafwa*, translated here as princess royal, is an important title. The holder is given the respect of a chief and represents him at royal functions. Domestic disputes throughout the country may be brought to her. She also organises women's activities – farming, recreational and (today) political. In Foreke Cha Cha the princess royal of the dead chief acted for many years as regent. The princess royal in Fontem today (Plate 6) is a powerful and admired personality; she was the support and solace of her father Chief Assunganyi through the last years of his reign. Married to one of her father's servants, she divorced and now has her own compound, her own 'wife' and a standing in Bangwa which is undisputed. The princess royal plays an important part in the mortuary and succession rites described in Chapter Four.

Chiefs and subchiefs depend very much on a body of servants or retainers who inhabit the palace precincts. Their origins vary: some are descendants of slaves. But even a free man could in the past become a chief's servant since palace service entailed material advantages which a man's father could not always provide. A slave had quite a different status from a servant. Retainers are ranked. Some look after the palace and the royal wives. Others supervise community work, collect dues or arrange the marriage of princesses. Some live within the palace and often acquire political influence through their close connection with the chief. A powerful chief trusts his servants more than his councillors or royal sons; they are often married to titled sisters of the chief.

A chief's major role is to judge. Aided by councillors (selected subchiefs and hamlet heads) and ranking retainers, the chief hears cases in the meeting-house at the palace. Rich and poor bring cases, payment being a gift of wine

Plate 6 Fontem's princess royal, Mafwankeng

and food to the deliberating elders. In cases which have no obvious solution various methods of divination or ordeal are resorted to. In the past, for serious cases such as witchcraft or suspected adultery, the fearful sasswood ordeal was conducted by the country's police society, the Night. The accused man or woman was given poison; if it was not vomited their guilt was proven and the society's masked men beheaded the victim by the river's edge.

The Night society plays an important part in the rites and celebrations described in Chapter Four. Its members are the Bangwa kingmakers. It is to them that the chief confides the name of his successor on his death-bed. They protect the palace during the often turbulent interregnum and present the successor to the people during the late chief's funeral celebrations (Plate 7). The Night society has sections. The lowest group consists of palace retainers; they perform executive functions such as collecting fines, punishing criminals, and placing injunction emblems (Plate 8) at the boundaries of disputed land. There is a section for subchiefs and nobles, who meet to discuss secret political matters. The inner sanctum of the Night society, the Great Night or

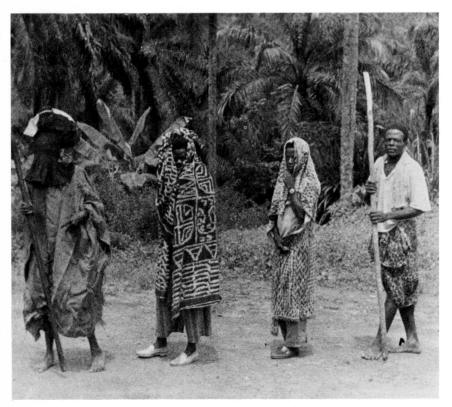

Plate 7
The Night society presents the new rulers to their subjects

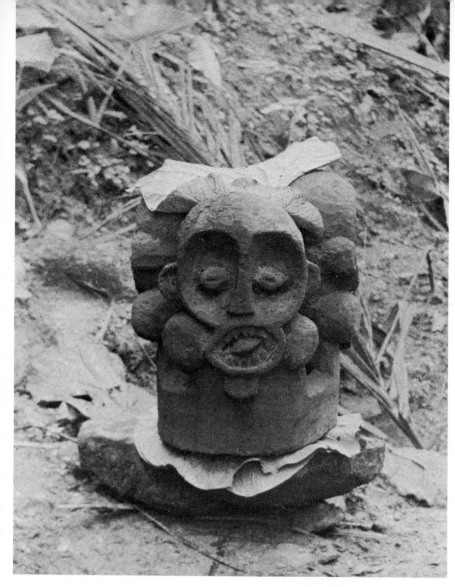

Plate 8
A Night mask as taboo
sign

the Nine, is a body of men who are the descendants of the original followers of the dynasty's founder and the highest-ranking royal retainers of the chiefdom. The Nine, today, are great nobles, descendants of princesses who were married to retainers. They are only technically servants of the chief, taking precedence at state councils and wielding great political influence. The position of these Great Night members was not always secure, since their power was so great that they were often feared as rivals to the chief. Several were accused of witch-craft or of plotting against the chief; traditions record that some were hanged or sold into slavery. The relationships between the chief and the Lord of the

Night society is particularly close, involving mutual dependence but sometimes also bitter enmity.

The Night society meets infrequently today, its functions having been taken over by the West Cameroon administration. In the minds of the people, this group, with its fearful role, its terror masks and mysterious midnight meetings, is associated with danger and the supernatural. The Nine accompany the chief on his supernatural exploits, joining other paramount chiefs and their retinues, transformed into leopards, serpents, rainbows and elephants, to perform feats of agility and to 'feast' on human flesh. These beliefs are involved in the Bangwa attitude to the society's emblems, the Night masks and sticks, which are discussed in Chapter Five.

The Night society is only one of many societies or jujus which play an important role in Bangwa social organisation. The societies are of many kinds and have political, economic and social functions. The Night society is a secret society, based on the palace and membership is strictly ascribed by birth. Sections of the Night society are also owned by subchiefs and nobles, who have their own Night retainers and their own emblems. Another old Bangwa society is the *lefem*, the word for the sacred copse where members meet to play their gongs. In the savannah Bamileke chiefdoms this society is known as *kwifo*; in this book it is referred to as the Gong society. Membership of the chief's Gong society is reserved to nobles and subchiefs although meetings and performances are not secret. Subchiefs also have their own Gong societies attended by their own nobles. Wealthy men may buy the gongs and the techniques of playing them from the palace.

The Night and Gong societies are ancient Bangwa societies. So are the warrior societies (*manjong*, Challenge and *alaling*). Other societies have been introduced into Bangwa by wealthy nobles and often play a completely different role in Bangwa from their country of origin. *Aka* (the Elephant society) is a secret society like the Night society among the Bamileke; in Bangwa it is for show only, being an association of the rich, with a slave as the membership fee. From the western forests other societies have been introduced mainly as recreational associations; they are popular at funeral celebrations and public occasions with their elaborate costumes and masks and joyous dancing and singing. All men are free to join for a nominal fee and even women join in the dancing during performances. Details of these societies (the Leopard, *massem*) are given in Chapter Four.

All of these societies are 'owned' by a chief or noble, membership being acquired by succession to a person's status or by the payment of a fee. In some cases the society itself, with its songs, accoutrements and dances, may be bought by a wealthy man; performances by his retainers, friends and followers will add

18

to his reputation as a 'big man'. Women play only a small part, although titled princesses are automatically members of the Night and Gong societies. However, since the early 1950s women have been organising themselves into societies, known as *ako*, which meet regularly and present their own masks and dances at funerals of both men and women.

THE FAMILY

The Bangwa trace relationships through both parents, although most property and titles are inherited patrilineally, and a man's heir is also the custodian of his skull. But there are no wide patrilineal groupings, no clans or lineages with a common name and marriage taboos. A patriline is primarily important to a man's successors; the other sons co-operate in the mourning ceremonies, quarrel over the inheritance and go their separate ways. Half-brothers own no property in common. Female links are stressed in the kinship system. Ideally a woman's property is inherited by a daughter and her skull becomes the focus of an ancestral cult of which the daughter is priestess. A female line is sometimes traced back several generations to a founding ancestress to whom sacrifices are made. The most important family relationships are those of a person's own kindred in which the solidarity of the 'children of one womb' and their children is opposed to the weak half-sibling relationship within the polygynous family. Non-kinship factors are also important and institutionalised friendship is common.

Children are born, named and grow to adulthood without any public ceremonies. In the past girls were betrothed soon after birth. This involved the future husband in a long period of service, mainly on behalf of his mother-in-law. Marriages are legalised by the concluding of the marriage payments and the transferring of the 'marriage goat' to the bride's kin. Bridewealth is high; about £200 on average in 1965. A large selection of relatives receive their share of 'goats', 'hoes' and 'salt', nowadays converted into Cameroon currency. The bulk of the money is shared between four persons, the bride's 'marriage lords'. They are her father, her mother's father, her mother's mother's father and her *tangkap*, her 'money father'. *Tangkap* needs special explanation. In Bangwa thinking, everybody is descended from a female slave. The successor of the man who bought her is their *tangkap*, or major marriage lord, and he receives multiple services and dues from his wards, both men and women. These include death dues and tribute as well as the important bridewealth rights.

Polygyny rates are high, more than fifty per cent of married men having more than one wife. This is made possible by a late marriage age for men: a commoner cannot afford to marry until he is in his thirties. A man's widows are inherited by his successor although some are handed out to unmarried sons.

The most common of the unnatural causes ascribed to illness and death is witchcraft, which may be divined or confessed by the witch. Witchcraft in Bangwa, however, is an ambivalent power and may be used for good or evil. Basically it is a belief that all men and women, even children, have the capacity to change themselves into animals or natural forces, for the purpose of bewitching their relations, or for the less anti-social activities of chiefship and medical healing. Witches can change into elephants, swarms of bees, lightning, aeroplanes, landslides. A witch preys on the flesh of living people causing their illnesses and deaths. Witchcraft also causes crop failure, sterility and drought.

Beliefs in the afterworld are complex. Dead men's souls go to the Bangwa heaven or hell, the good and bad countries below the earth. The sky is the abode of witches, not angels. Ghosts of the dead return from the grave to haunt family members and are exorcised by a simple lustration rite. Ancestors are worshipped through skulls. There is no regular skull cult, individuals worshipping their ancestors through the mediacy of the successor of a patriline or matriline. The skulls of the chief's ancestors receive special treatment; on a special day of the week the chief or the princess royal sacrifices to the skulls to the accompaniment of a carved elephant horn blown by a palace retainer (Col. pl. 8). While the ancestors are the most vital spirits, each adult also worships at a shrine dedicated to his personal spirit guardian.

THE ECONOMY

The Bangwa chiefdoms are able to participate in the advantages of two distinct ecological environments, having boundaries with the high savannah to the east and the low forest to the west. Even within the chiefdoms there is a kind of dual division between the highlanders and the 'down' people. The former put a premium on hierarchical political organisation and rank. It is they who own the palm groves in the forests; in the past they sent their slaves and servants to supervise oil production. Highlanders are proud and independent; they despise farmwork but are consummate politicians, dancers and artists. They consider their lowland countrymen to be steeped in the magic and witchcraft of their Banyang and Mbo neighbours.

There are two seasons, a wet and a dry. The dry season is short, lasting about four months and beginning in December. The soil is volcanic, a tenacious red clay of limited fertility. In the highlands the less dense forests have been cleared for intensive agriculture but in the forest regions shifting cultivation is the rule. Climatic variations within each chiefdom are due mostly to sudden altitude changes: a few hours' climb and topography, climate, flora and fauna undergo a complete change. The women carry out subsistence farming, travelling many

steep miles up the hills to plant maize, beans and groundnuts and towards the forests for cassava and cocoyam farms. Cocoyams are the staple. Clearing, even of heavy bush, is done by the women themselves, sometimes with the help of an adolescent son or an obliging son-in-law. A hazard comes from the roaming livestock (goats, sheep and cattle) owned by their husbands. Men show no interest in farming apart from growing plantains round the compound, though they have recently started coffee farms in the highlands and cocoa farms in the forest areas. The production of oil forms one of Bangwa's biggest exports to the Bamileke grassfields. Other permanent crops include kola, avocado pears, Indian bamboo and two kinds of raffia. Palm wine is made from raffia and 'date' palms. In general land is a 'free good' although the chief is nominal owner of the land. A compound head has a fenced area used for garden crops, plantains and, today, coffee. Most women depend on a share of a farming tract divided annually by their chief, plus farms in other hamlets, since certain areas are valued for certain crops. Six or seven smallish farms prevent the calamity of a crop failure in one area. No payment is made to the 'owner' of the land.

Much of the internal trade is also in the hands of women who carry smoked meat and fish, cocoyams and oil to the east, returning with palm wine, groundnuts and maize. There is a general trading pattern from Banyang forest market, to Bangwa market, to the grassfield market. Royal wives, who are forbidden to carry out long-distance trading expeditions earn their pin-money by trading foodstuffs in their local markets; cocoyams, cassava flour, maize, beans, kola nuts, etc. With these small profits they are able to buy quantities of salt, meat and oil to supplement their husband's contributions. Women who trade more extensively can afford to buy European household articles and cloth and contribute to their children's schooling.

The flourishing Bangwa economy has always depended primarily on trade. There are many markets. In Fontem, with a population of less than 10,000, there are four important markets and half a dozen others are attended regularly. A market is established by the chief planting a 'fig' tree in an open place before the palace and sacrificing a goat which is buried below it. The chief protects the markets though he himself may never enter it. He sits with his retinue outside the palace to receive the compliments or complaints of his subjects. A royal servant makes announcements after sounding the 'slit-gong (Plate 9). Palm wine is sold in prodigious quantities from tiny stalls. Cattle and pigs are slaughtered and sold in one section, smoked game and fish in another. Solidly built shops are now slowly springing up round the market squares but sites are difficult to acquire, especially for strangers.

External trade is carried out by men. Apart from the always important trade in salt, oil and other subsistence goods, the Bangwa acted in the past as middle-

men in the commerce of slaves, guns, European articles and prestige articles made locally. Currencies used were trade beads, iron rods and to a lesser extent cowries. Slaves were bought in the east and sold to Banyang or Keaka (Ekoi) traders for sale in Cross River markets. Some slaves in Bangwa came from as far afield as Fumban. People alive in Bangwa today testify to having been kidnapped as babies in the grassfields and sold there. The chiefs were the principal traders, acting through retainers, and many private fortunes were made by commoners. The whole structure of Bangwa society depended on the slave trade; much of its present structure is a result of it. Slaves were on the whole well-treated and frequently rose to positions of wealth and political importance. Descendants of slave-retainers are now important subchiefs. No stigma is attached to slave parentage.

Bangwa men were warriors in the past. Now they are also oil-producers,

hunters and rearers of livestock. Traditional specialised activities include those of the diviner, priest, healer, smith and carver. Nowadays there are also tailors and carpenters. The Fontem blacksmiths are well-known in the Cameroon grassfields. The craft traditionally came to Fontem during the slaving period. The ancestor of the blacksmiths (the craft is preserved within a family) was bought by a Fontem subchief and, when his prowess at making the double gongs used in the Gong society and the Bamileke *kwifo* societies was discovered, he was transferred to the palace of the paramount chief. At first the blacksmiths worked exclusively for the chief. They sold domestic objects (knives and hoes) in the market, but the magical gongs were only sold through the palace. The Fontem blacksmiths are still nominally royal servants but their goods are sold independently of the chief today.

Another specialised role is that of the artist.

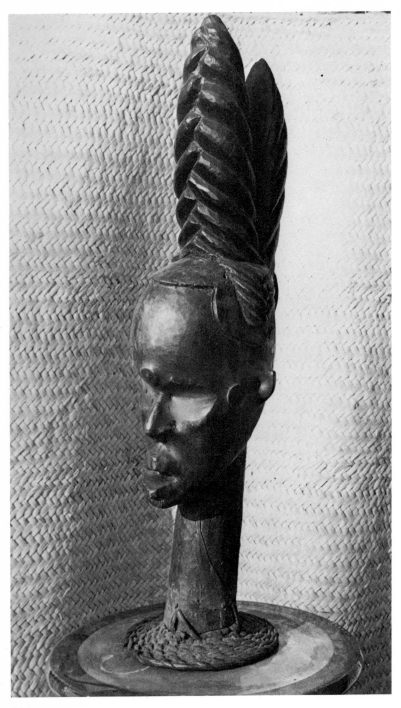

Plate 10

A Challenge mask. The smooth flesh of the face is skin-covered. In the possession of the authors, it was bought with only the remnants of skin attached to the mask and was re-covered by a local expert. The skin used was that of a ram, colour being added afterwards (camwood powder). The tribal marks are shown by small discs of gourd pinned to the surface of the mask. The skin is attached to the wood by tiny bamboo pins in the ears, behind the nostrils and under the chin. The eye hollows were left unadorned, shadows giving the impression of eyes in a remarkable way. The head-dress exaggerates the elongation of the mask. The origins of this mask are not certain since it was bought in Fontem from a trader and may be from the western forest regions.

CHAPTER TWO

Art forms

Bangwa lies at the watershed of two important culture areas – of the Bamileke of the savannah on the one hand, and of the Ekoi Cross River group of the West Cameroon forests and Eastern Nigeria on the other. Culturally the Bangwa are heterogeneous, although their language and social organisation ally them with the Bamileke. Bangwa art, it will be clear, has affinities to the art styles of both areas: local sculptors are expert both at the manufacture of the forest-inspired skin-covered head masks and at the savannah-type portrait statues. One problem is to determine how far this group of nine miniature chiefdoms can be said to have its own distinctive art style. The Bangwa are a very mobile people, receptive to ideas and inspiration from all points of the compass. It is therefore difficult to isolate one style or tradition stamping each work of art.

From the forest, particularly from their nearest western neighbours the Banyang, the Bangwa have acquired a number of secret societies, with their associated masks. The Cross River style is evident in the skin-covered, horned masks of the Challenge (Plate 10) and Royal societies. It is also apparent in the crude fetishes associated with anti-witchcraft cults which have been sweeping through Bangwa from these areas over the past generation. Bangwa witchcraft beliefs, associated with shape-changing, are closely akin to forest beliefs. The latest importation from the west has been a series of societies or jujus the most typical of which is the Leopard society (see p. 107) which can

25

be traced as far as Calabar in Nigeria. Masks associated with these societies (Col. pl. 18) are the ebullient, polychrome helmet masks now being made in Bangwa both for home consumption and for the forest tribes themselves.

A style verging more on the Bamileke style is evident in the ancestor figures, the mother and child figures and the *kungang* anti-witchcraft fetishes. These are described in detail on pp. 127 ff. Carving associated directly with chiefship – royal paraphernalia such as stools, trumpets, house decoration – can be found in more or less the same style from Fontem across to Dschang, Bafoussam, Bandjoun and Fumban. The regional variations become clear only after close inspection. Thus the work of a Bangwa sculptor which is illustrated in Col. pls 8 and 9 and Fig. 3 is clearly Bamileke in style, and yet the artist has been able to give it his own individuality. The diversity of form and theme throughout Bangwa art, however, makes the definition of an exclusive Bangwa style difficult.

The precipitous mountains have not prevented an infiltration of ideas and institutions from the forests to the grasslands. The Bangwa entered this in-hospitable region precisely in order to form a commercial bridge between the oil-rich forest lands and the populous slave entrepôts of the Bamileke plateau. As in trade so in art; the Bangwa form a cultural link between these disparate peoples. Expressionistic influences, alongside witchcraft beliefs, entered the Bamileke area, mediated by the Bangwa artist. Many of the styles of imported associations remain distinctive of their place of origin: this is particularly true of the Challenge masks. Yet Cross River influences are found in the chiefly statues: the chief's head on the trumpet illustrated in Plate 11 has cicatrisations usually associated with the forest peoples; the figures of the *kungang* society have Bamileke-type facial characteristics with Cross River body-form (Plate 12). In the case of the Night society masks there appears to be a complete merging of the two styles into something distinctively Bangwa, difficult though this is to define. It is a subtle amalgam of two powerful art styles, each affecting the other. This aspect is treated in some detail in Chapter Five.

The problem of the origins of art objects is not confined to specimens in museums in Europe. Even locally it can never be confidently said about an old piece that it was made by the Bangwa. Today Bangwa sculptors carve in two traditional styles – one can be called the Cross River style, the other the Bamileke. But in Bangwa anything is and can be traded, even objects of art. In the past even the sculptor himself could be exchanged by his master for slaves or trade objects. Hence while the only solution is to accept the local tradition as to what was or was not made in Bangwa, material wealth of all kinds has travelled along the slave and trade routes that link Calabar and the Cross River districts to the eastern Bamileke chiefdoms and Fumban in the

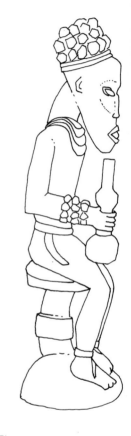

Figure 3
Ancestor figure

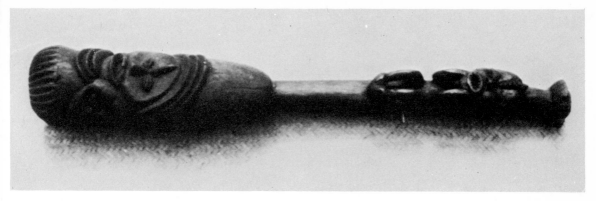

Plate 11 Trumpet of the Gong society; note the cicatrisation on the forehead of the face

Plate 12 *Kungang* fetish figure and its dog servant

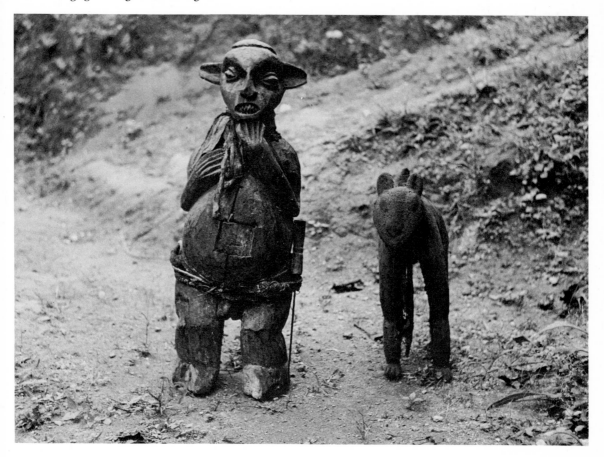

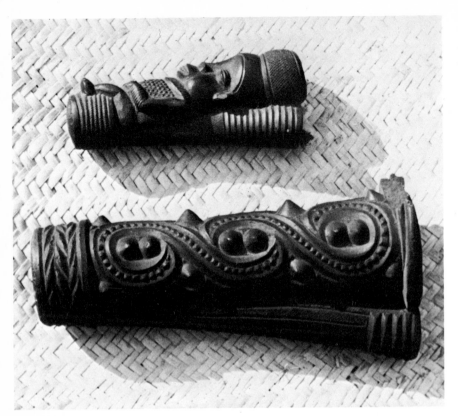

Plate 13
Clay pipes of the type
often represented in
Royal portrait statues

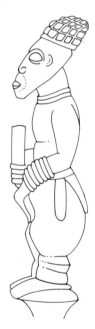

north-eastern savannah. Many ornaments worn by the Bangwa today were bought years ago in Bamileke markets. *Cire-perdue* objects (pipes and bangles) derive from as far afield as Fumban. Elaborate pottery is not made in Bangwa today; the pots occasionally made by the women now are of much simpler design than the beautiful old eating bowls used ceremonially at special feasts. There are many examples of clay pipes (Plate 13) which are said to have been made locally but which are no longer made today. There are no present-day bead-workers; yet the Bangwa claim the elaborate calabashes and beaded fly-whisk handles as their own work (Fig. 6). There is still doubt about all these objects. However, about most carved masks and figures there can be none. Specific details are known about each figure, sometimes even the name of the carver. Masks in the same style as the old ones are still being made.

The types of art objects to be discussed in this book are primarily masks and figures. The function, form and value of these objects vary. Bangwa art can be utilitarian, or it can be religious or sometimes purely aesthetic. The imposing beauty of a portrait statue is a positive attribute of its supernatural sanctions.

Figure 4
Ancestor figure

The expressionist strength of a secret society mask reflects the privileges and powers of chiefship. Art for art's sake exists in the fabrication of elaborate ornaments. We have confined our attention to sculpture which appears at a mortuary rite. Discussion of domestic arts, personal ornament, painting, decoration and architecture has been excluded.

Bangwa figures are discussed separately in Chapter Five. They include ancestor statues (Figs. 4, 5), mother and child figures and fetishes. These are the figures which have achieved fame in the primitive art world. Few of them are left in Bangwa, the last collectors' raid having taken place in recent years. Many photos were taken in the field in 1965 (Plate 14), since when they have disap-peared to unknown museums and private collections. Others were photo-graphed in 1967 with the reluctant permission of their Bangwa custodians. Some of the chiefs now refuse to show visitors their treasures; they fear the pester-ing of traders; and they fear, with some justification, that money-hungry rela-tives, by fair means or foul, will sell them to marauding collectors. Patience and persuasion are needed to see and record these figures. Photography is very diffi-cult when one may only be allowed a brief look at a dirt-encrusted figure kept in the dark recesses of a windowless hut.

Of an average height of three feet six inches these figures, portraits of royals and their retainers are associated with the royal ancestor cult and the Gong

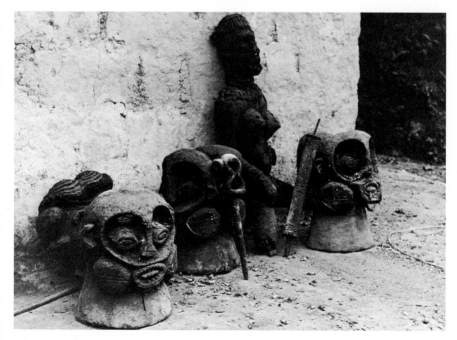

Figure 5
Ancestor figure

Plate 14
Night masks and a portrait statue of a minor Bangwa noble

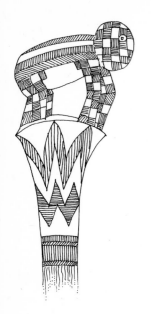
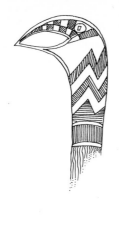
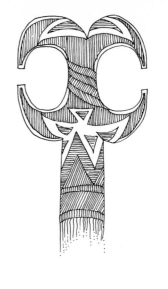
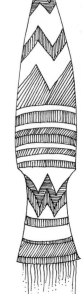

Figure 6
Four beaded fly-whisks

society (Col. pl. 9). Another type of figure, the fetish, is distinguished by a form which has zoomorphic features, a swollen belly and bent arms and legs (Figs. 7, 8). The symbolism involved in these anti-witchcraft figures is discussed in Chapter Five. Only these anti-witchcraft figures are true fetishes, with autonomous powers, though some masks of the Night society seem to lie midway between the notion of a ritual object (which is a vehicle for supernatural action) and a fetish.

The bulk of the art objects consists of masks. These masks are associated with societies which fulfil vastly different functions. The masks of the secret Night society are made to inspire terror and symbolise both the supernatural and the earthly powers of the society. Others provide entertainment. Some are surrounded with secrecy and seen only on rare occasions. Others are treated casually, lent to other groups and brought out frequently. On the whole a Bangwa masquerade is a secular affair and the masks do not perform a heavy symbolic task. Apart from the masks of the Night society they are not ritual instruments (nor 'totems' of secret societies) but part of a public entertainment. These masks perform in a simple masquerade and are valued purely for their beauty and theatricality. They are even medicated to make their theatricality more effective

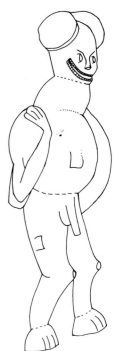

Figure 7
Fetish figure

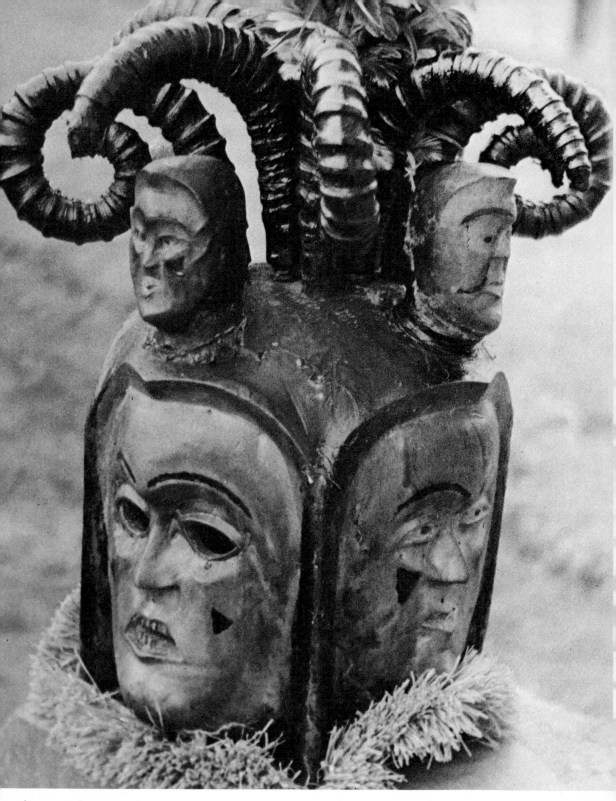

Plate 15 Royal society mask

(see p. 56). These entertainment masks, however, are treated almost as cere-moniously as the Night masks. They arrive at the venue of the cry in an aura of exaggerated secrecy. No child is allowed to touch them. They appear on the field with splendid panache.

The Bangwa word for mask is *atu* (head), in which is included many types of head disguises, even masks made of cloth or beadwork. This is the sense in which the term mask is used throughout this book. Face masks of the 'classical' types are rare: they are in fact found only in association with the society of royal spies (Plate 47) and in two examples of Night masks (Figs 31, 32). Helmet masks are worn by members of the Royal and Leopard societies; they cover the face completely and are often two- or four-faced (Plate 15). Another common type of mask, associated primarily with the headhunting society, Challenge, is worn on top of the head, the face being covered with a veil attached to the basket-work which forms the base of the masks (Plate 16). The Night masks are anomalous: they are made to be worn on the head in either a vertical (Plate 29) or a horizontal (Plate 64) position, sometimes even tipped forward obliquely over the forehead. In fact in Bangwa they are never worn. These 'masks' are carried in the arms or on the shoulder. In some examples the sculptor scarcely attempts to carve a head hole. Disguise for the members of the Night society is a knotted hood (Plate 36).

The masks vary in form as well as in function. Some are light and small, others heavy and larger than life; some naturalistic semi-portraits, others expressionistic symbols. Some (the Night masks) are left shrouded with leaves in dark corners; others are made to be danced with and to be seen in bright sunlight. Some are in bright polychrome; others have a natural patina from smoke and the blood of sacrifice. Some are made to be viewed frontally, others to be viewed from all angles.

On the whole the masks of each juju are similar in form. Those of the Night society are large, unpainted, and generally abstract. Those of the society associated with royals are Janus helmets, covered with skin and stuck with ornaments. Those of the headhunting groups are small, skin-covered head masks. The Leopard society uses brightly painted, grimacing helmet masks. The Elephant society dances only in beaded masks – the Warrior's society in appliqué ones. Like the society itself, the art form is imported and adapted by Bangwa artists to the new environment. The only masks which can claim to be at all indigenous are those of the Night society and the Royal society.

With all the mask-types the time factor has also to be considered. The style associated with a type of sculpture varies from time to time. Today, the Royal helmet masks are carved in a form similar to those of the Leopard society. These changes do not apply only to the recent effects of European penetration.

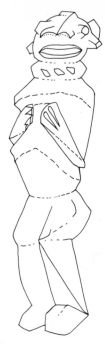

Figure 8
Fetish figure

32

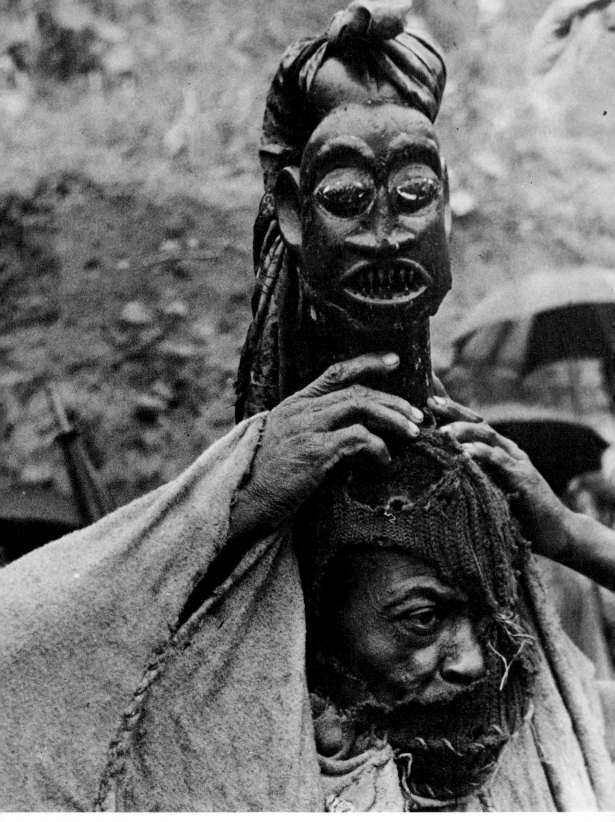

Plate 16 A Challenge mask during the dance

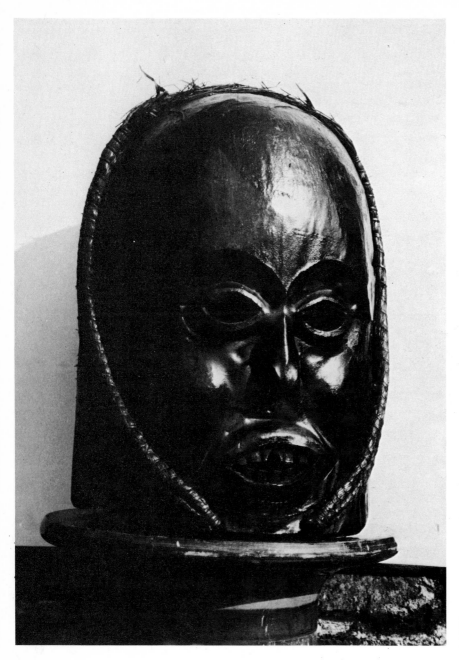

Plate 17
Helmet mask of the
Royal society

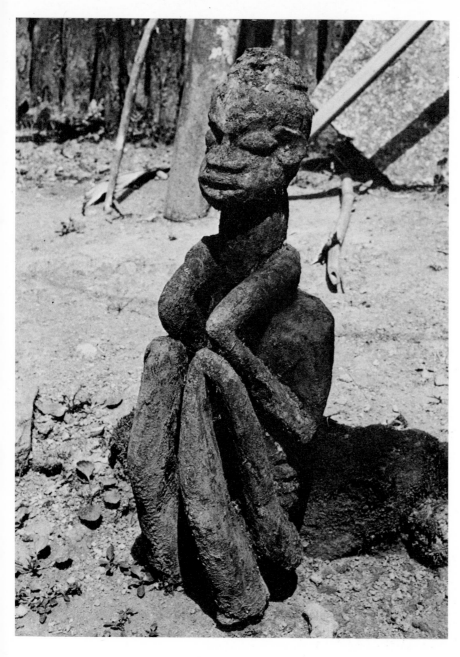

Plate 18
Kungang fetish figure
with typical bent arms
and legs

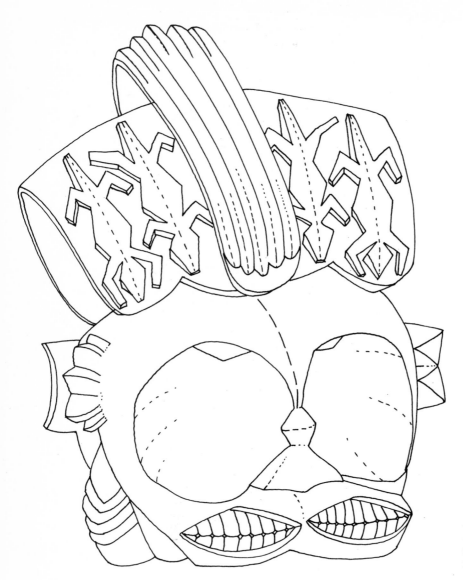

Figure 9
Double-sided Night
mask. Note the two
mouths

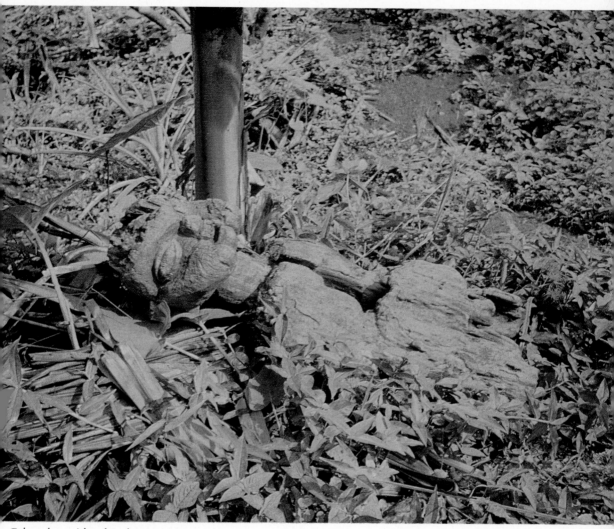

Colour plate 1 Abandoned ancestor figure

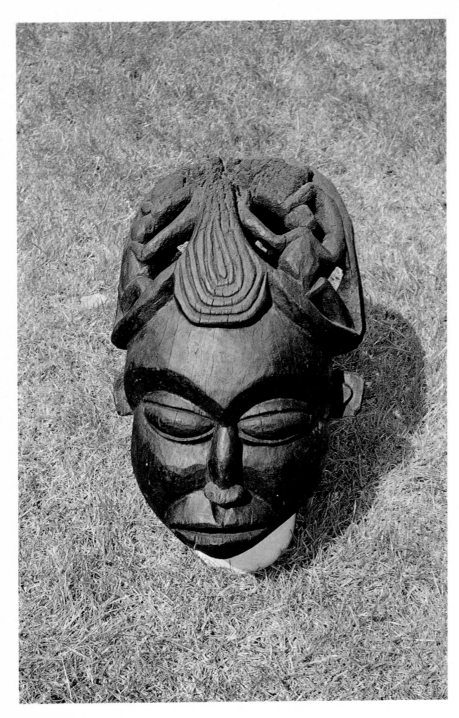

Colour plate 2
Night mask

Despite the astonishing diversity of sculptural form there are stylistic themes running through all the masks. Some are not specifically Bangwa, but common throughout West Africa. These include masks of the 'heart-shaped' and 'pole-shaped' tradition[1]. In the heart-shaped masks the face is contained within a heart-shaped line extending from the twin arcs which form the eye-brows down round the cheeks to converge at the mouth or chin. In pole-shaped masks, the mask is carved from a cylindrical block of wood, whose shape is not significantly transformed by the sculptor. Both methods are illustrated in the Royal mask in Plate 17.

The Janus mask is another common form. Janus masks are found in most of the societies, including the Night society, but are primarily associated with the Cross River-style masks of the Royal, Leopard and Challenge (head-hunters) societies. The Royal helmet masks may be two-, three- or four-faced. The faces are similarly carved although sometimes the front receives greater attention and only the front eyes are opened (Col. pl. 3). No symbolic expla-nations of this type of mask exist. 'We make them like that so that they should look fine.' The masks of the Night society, on the other hand, have one, two or four sides and the Bangwa give these an explicit symbolic explanation. They are said to be associated with the rank of the noble who 'owns' the society. Only a paramount chief is allowed to have his masks carved with four faces. In rare cases a Janus mask is given four faces by the portrayal of two faces simultaneously on each side (Fig. 9). Through the two or four faces of the masks of chiefs and subchiefs the society symbolically surveys the whole land, keeping its four or eight eyes on witches, seducers of royal wives, and thieves.

In normal times important sculptures are not open to public view. They are stored in the inner recesses of a palace courtyard or in the hut of a retainer living outside the palace. In some cases gifts (including a chicken and tobacco) must be given to their custodian before they can be seen. The most powerful fetishes are kept secretly and are brought out only when an accusation has been made against an individual or a group of kin. Only the people involved in such accusations in fact ever see these works, except during important annual anti-witchcraft rites or a chief's mortuary rite, when they are brought out to protect the compound. Some fetishes are never seen. Their whereabouts are known and stories are told of their exploits; but their owners refuse to let them be exhibited. Lesser fetishes fashioned to protect compounds from evil spirits are displayed prominently in the forecourt. These are usually of poor craftsmanship (Plate 18).

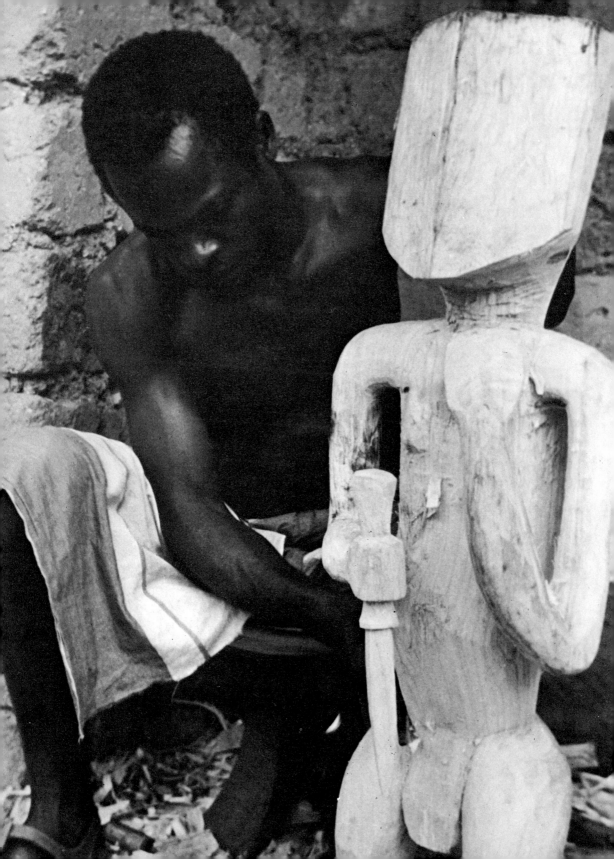

CHAPTER THREE

The artist

As artists the Bangwa are unsurpassed anywhere in the forest and upland areas. Even today their reputation is high; it is to the Bangwa carver that the societies of the Banyang villages and the chiefs of the neighbouring Bamileke chiefdoms come for their masks and ornate stools (Plate 41; Figs 10, 11, 12).

Carving is regarded as an honourable occupation both for commoners and nobles. Professional carvers exist (Plate 19) who have been trained from childhood and who earn their living exclusively through this craft. There are also innumerable amateurs. In fact there is scarcely a man among the Bangwa who has not tried his hand at some time at a mask, statue or anti-witchcraft fetish (Plate 24).

For chiefs and other royals, farmwork, smithing, trading, housebuilding and other occupations are still considered undignified: in the past retainers traded for them, supervised oil production in the forests and organised other profitable ventures. While commoners today are making fortunes from their coffee plantations, many chiefs are too proud to be seen hoe in hand like a woman, on their farms. A chief's business is politics, and it is an arduous one. He is available throughout the day – even the night – to settle disputes in his compound and among his subjects. Carving is a pleasant relaxation to occupy him as he patiently attends interminable palavers or conducts witchcraft inquests. Chief Fontem is often at work on a small carving in the house where he receives petitioners and disputants: an ivory ring, perhaps, or a fixture to be added to a complete mask. He frequently puts the finishing touches to masks

Figure 10
Royal stool

Plate 19 The Carver

sold under his aegis at the palace. He dyes plumes for the helmet masks of the Royal society (Col. pl. 3); he makes detachable horns and does skin-covering. Before his father died (in 1951), he was a full-time carver, and it is his constant regret that he has not more time to devote to it now. In the past chiefs encouraged their sons to take up carving, as a dignified means of earning a livelihood. They were trained by the resident retainer-sculptors and their work was sold in different chiefdoms, particularly in Eastern Bamileke. Some knowledge of techniques which are disappearing is preserved by royals – as is also the ability to sing or play some of the more esoteric musical instruments and old songs.

THE PROFESSIONAL CARVER

The most important group of carvers was and still is the professionals. In the past many of them were slaves; or at least this is the tradition. Deals were made between individual chiefs to sell, for a price, valued slaves who were proficient blacksmiths, carvers and so on. In this way a wealthy patron of the arts, like the chief of Fontem in the nineteenth century, could acquire his artists ready-made. This is true of the founder of the Fontem blacksmith group. On the other hand, exact details of the origins of famous carvers are not known, the Bangwa merely saying that a certain man was 'owned' by the chief. This implies that the man worked exclusively for his master, selling his work through the palace and occasionally being 'loaned out' to other chiefs to carve a portrait figure or a set of Night society masks. It is a curious fact that, in spite of the large prices demanded in the past for the work of an accomplished sculptor (usually a slave for a statue, the Bangwa say) none of the famous names has been perpetuated in large families. The chiefs say that a retainer-sculptor worked for them. He was rewarded by occasional gifts from the palace and the free presentation of a wife, usually a royal ward. Payment was made to independent carvers in traditional currency (beads, iron rods and to a lesser extent, cowries).

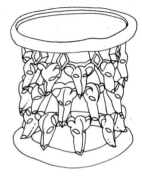

Figure 11
Royal stool

Bangwa sculptors are free men today, of course. They are, however, not necessarily free agents, but retain important connections with the palace. Some of their work including important items of royal paraphernalia to which sumptuary laws apply, may only be carved in the palace and sold by the chief. Work made from ivory or leopards' teeth is carried out under close palace inspection. The leopard and the elephant are important royal symbols, and in witchcraft beliefs the most common transformation for members of the family royal is into these animals. If a leopard is killed it is brought to the chief and elaborate rites are carried out before the animal is apportioned among the country's nobles. The chief takes the pelt, the whiskers (the latter being an important ingredient in royal rituals), and the teeth, which are fashioned into

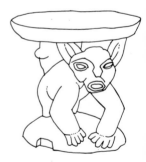

Figure 12
Royal stool

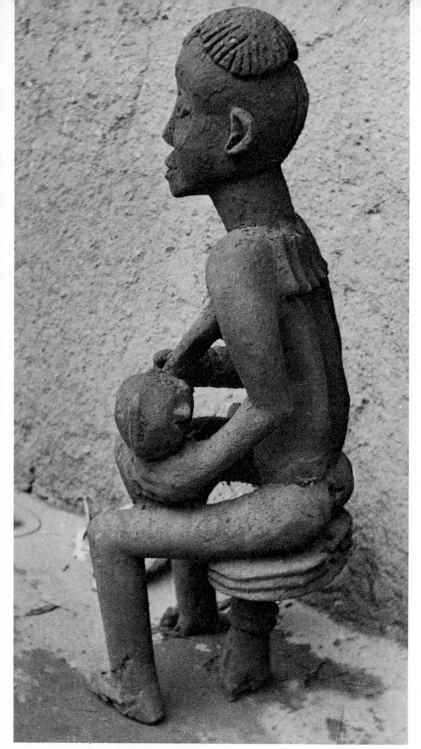

Plate 20
Mother and child figure.
Note the leopard's
tooth necklace

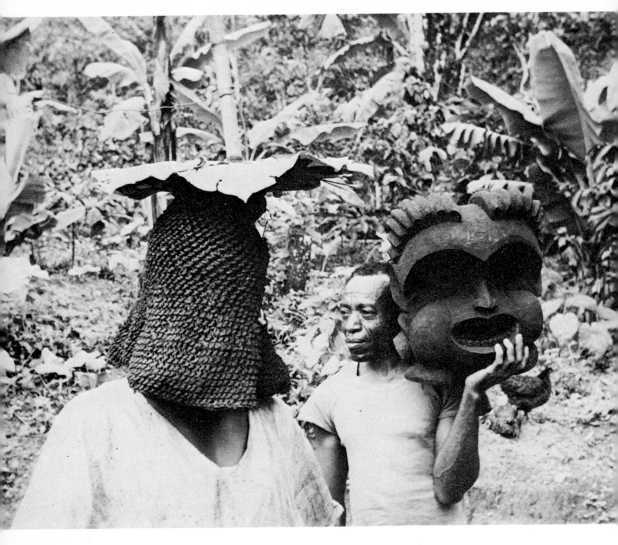

necklaces. They are worn by ranking royal retainers and on ceremonial occasions by mothers of twins (Plate 20). The leopard, as a symbol, is incorporated into utensils associated with the Gong society (Fig. 13), and into royal stools (Figs 10–12). From the tusks of the elephant, horsetail whisks (Plate 23), armlets and rings are made which only chiefs may own. Ivory was sold as a monopoly to forest traders in the past; today it is only bought, expensively, through the chiefs. Objects made from it by local sculptors are carved inside the palace and are only occasionally sold to distant nobles at the discretion of the chief.

Plate 21
A modern Night mask, carried by the Lord of the Night and preceded by a Night masker

Some carvers prefer to use the chief as their agent, and will stress a kinship or retainer connection with him to bolster their link with the palace. The chief carries out an important service, buying the masks from the carvers and selling them to his subchiefs and other paramount chiefs for what he can get. He may also commission figures and masks for his friends and, nowadays, for Europeans. There is a polite fiction at the palace that the chief himself carves everything for sale. Chief Fontem who, as we have seen, is a carver himself, encourages good craftsmanship. He is astute as well as artistic. At a time when standards are slipping, as both professional and amateur carver rush to capitalise on the sculpture boom, he alone insists that the proper wood be used, that skin-covering is done with care and that masks are correctly finished off.

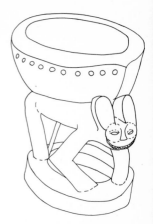

Figure 13
Eating bowl used in Gong society feasts

TWO SCULPTORS

The best known of the Bangwa carvers today is Atem. He leads a free-and-easy life – his prowess with the adze and his devotion to pleasure are equally renowned. When not working he lives for the moment. Once a mask or drum has been completed and the money handed over, the money is mostly invested in drink, which he shares with his crowds of friends. Unusually for a Bangwa he is uninterested in other material comforts. He works in a small decrepit wattle-and-daub hut miles away from the Bangwa centres. A visit to him and his young apprentices involves a steep, muddy trek to a forested mountain slope in Upper Bangwa. In spite of his many opportunities for wealth, he has only a single wife. This is startling to a Bangwa, whether Christian or not, since a man's success is usually determined by the number of wives housed in his compound. Atem carves more and more for wealthier patrons outside Bangwa. He carves masks for Banyang societies and royal stools for neighbouring Bamileke chiefs. He is even sought after in the cultural *foyers* in the French dominated towns of Yaounde and Douala, and he has made a stool for the wife of the President of Cameroon. Although he travels widely ('to drink', he says) he returns home to work. Chief Fontem, as marriage lord of his mother, is a 'father' of Atem. This connection with the palace justifies the chief's acting as his agent in selling his work to visitors to the chiefdom.

Atem carves masks primarily for the Bangwa jujus described in Chapter Four. Plate 21 shows a Night society mask carved by Atem in 1967. He prefers to carve masks associated with jujus which have been recently imported from the forest areas (Plate 43); these are the dance societies which are most popular with Bangwa young men today. He is commissioned by the society, the members of which contribute money to pay for a mask which may cost anything from £3 to £15. These are usually Janus-headed, horned masks, painted in brightly coloured European hues. They are lively, extrovert and

43

amusing, a far cry from the expressionistic Night masks or the serene memorial figures of the old artists. Atem also carves drums, vast slit-gong drums which he works *in situ* in the forest, often simply following the shape of the tree trunk from which they are cut; they are then hauled complete to the owner's compound. Other drums are elaborately decorated at the ends; there is one which has the portrait of a chief and his princess royal at either end. Atem is also an expert musician as well: the 'sound' of the drum is important as well as its appearance. His favourite diversion is a cry-die. He is a fine dancer and a virtuoso on the drums. Col. pl. 12 shows him performing on a slit-gong.

Ben is another well-known carver. Like many other artists he is considered odd by his friends and relatives. He is separated from his wife, a woman older than himself, a widow of the late chief of Fontem. He is a wanderer, living in different parts of the country and rarely to be found by his enthusiastic patrons. He is an introvert, and very 'religious'. He carves madonnas Plate 22 and Christ figures alongside fetishes. His main interest is the supernatural and he is apt to be swept up by any fad. His best work is done in ivory, such as the chief's royal fly-whisk handles (Plate 23). These are made at the palace and sold to other paramount chiefs – the wealthy coffee-planters of the Bamileke grassfields. Ben is a member of a retainer family still closely attached to the palace and when in Fontem works under the supervision of the chief.

Ben and Atem are typical of the individualistic carver working on his own. Bangwa society gives free rein to individuals and even by their standards the sculptors are allowed great unconventionality. Famous carvers of the past are remembered as 'Bohemians' – wits and personalities who refused to conform to Bangwa norms. Nevertheless the Bangwa 'Bohemian' artist is not as much of an outsider as he may be in Europe. Art in Bangwa is a job like any other, a job a respectable man would be proud to see his son take up.

THE 'BLACKSMITH' GROUP

In Bangwa there are no artists' guilds and few families of artists. Techniques may be passed on from father to son, from uncle to nephew, even from father-in-law to son-in-law. But carving is a career for the individual which anyone may take up. The Bangwa have no lineages. Rarely do groups of related kin live together in extended families sharing a common economy or craft.

There is one case, however, of a kin-group co-operating in an artistic enterprise. This is a group of carvers and feather-workers which centres round the head of the Fontem blacksmiths, Ngangala. Members of this group are, of course, primarily blacksmiths, a craft requiring co-operation and the hereditary transmission of skills (see p. 40). Almost as a side-line this group has taken up

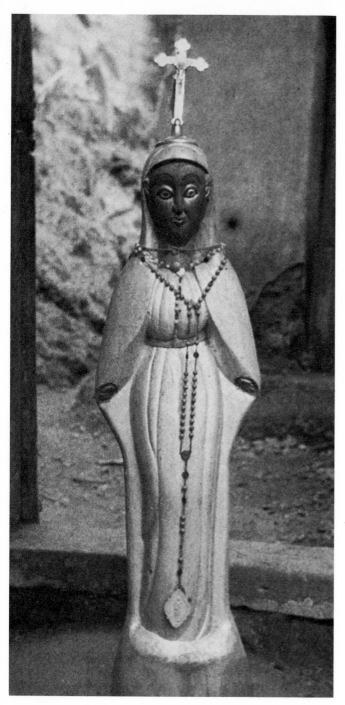

Plate 22 Madonna

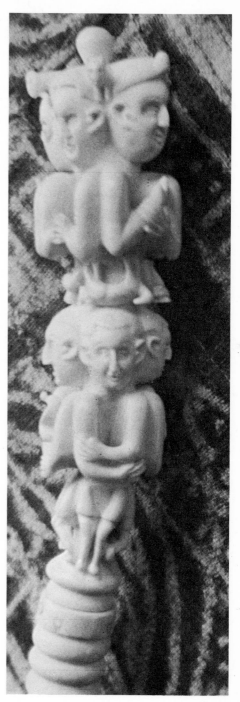

Plate 23 Ivory fly-whisk

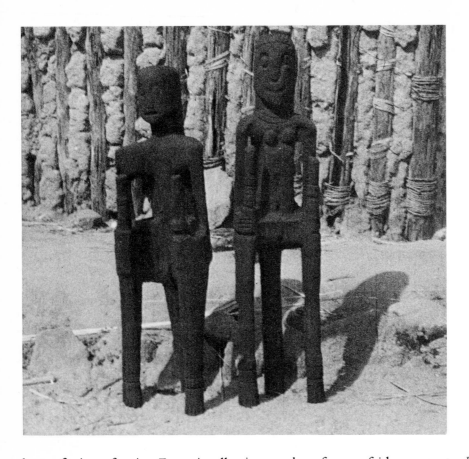

Plate 24
Carvings by a Bangwa
amateur, made in response
to European interest

the profession of artist. Exceptionally, its members form a fairly compact
residence group and are related to the head of the blacksmiths through diverse
kinship ties. Three of the artists in this group share a compound, each with
an independent wing. On the whole they work separately, each specialising in
a different branch of art. One young man carves figures; his own father was a
famous carver of the skin-covered masks associated with the Royal society.
Another, the owner of a sewing machine, makes the brilliant patchwork
costumes of the *massem* society. Another is widely renowned for his feather head-
dresses.

The blacksmith group keep up their former connection as retainers of the
chief. As the only semi-organised Bangwa artisan group they have taken a
lead in the very new Bangwa business of selling old and new works of art,
to outsiders. This they do primarily through the chief, who stores their work,
as it is produced, in his wives' huts. It is only in the last few years that carvers
have begun to make series of masks and figures to be sold to casual buyers.

46

Copies are now made of famous masks; scores of them may be seen in the palace cluttering up a food rack receiving their preliminary smoking from a wife's cooking fire.

THE APPRENTICE

A child who shows talent while playing with a piece of wood and his mother's kitchen knife may be sent off by his parents as a casual apprentice to an established carver. Atem has two ten-year-olds as apprentices. To begin with they help with the unskilled work, preparing blocks of wood and sharpening tools, as well as working about the compound and running messages. Then they are given the humdrum jobs, such as the initial hollowing out of some of the larger helmet masks. All the time they are expected to watch the master. He gives them independent work to do: repairing an adze for a neighbour or making a wooden spoon. They help with the decoration of the mask: dyeing skins, carving horns, painting. They make simple masks for their young friends, since children also have masquerades which they perform for their elders' amusement. Only those who show real talent are encouraged to take up sculpture professionally. Others are sent away; or they may train as craftsmen – making domestic implements for the market only. The young apprentice who has a flair begins to copy his master's work. Then he makes his own, adding his own ideas. Youthful work is given full praise by the Bangwa if it is deserved and originality, within limits, is encouraged. Gradually the young sculptor receives his own commissions and leaves his master. Payment for any kind of apprenticeship is variable; for a kinsman it may be merely services and a nominal gift; for a non-kinsman the sculptor may be promised up to £25, plus various gifts.

PATRONS

Masks and statues are normally commissioned. The patrons of Bangwa sculptors are chiefs, lesser nobles, dance societies and cult associations. If a mask or an ancestor memorial is commissioned by an individual the carver works in his patron's compound, where he is lavishly entertained until the work is finished. Small drums are also carved in the compound. A noble with a newly acquired title must also have the emblems associated with it: a series of masks for his dance societies, and the terror heads associated with his regu-latory Night society. Some of the objects – those that are ritually important – must be carved in secret and this is best achieved in the owner's compound. In the past the portrait memorials and the Night masks were carved with strict attention to sexual and food taboos; having the carver work in the palace meant that these taboos would not be accidentally or wilfully transgressed.

Nowadays Bangwa patrons say that sculptors are of such an irresponsible character that the only way to make a sculptor finish the work is to seclude him in the palace and allow him out only when the job is finished.

Today payment is made in cash, accompanied by innumerable gifts of wine and food. A contract is made before the artist begins the work, but if the group who commissioned it is particularly pleased an additional payment may be made on completion. The amounts for a statue or mask are not small, ranging from a pound or two for a small head or face mask to £15 or £20 for a figure. The great carvers of the past were only paid in slaves, it is said. A figure will be pointed out which cost, according to the owner, a 'wife'. Since bridewealth today is anything up to £200, prices for works of art may be said to be falling since a new ancestor statue may be bought for £30 today.

The works of the artist who makes ceremonial objects are not sold in the open market. Another group of carvers, regarded as craftsmen pure and simple, make domestic implements for sale in the market. These include many objects; two kinds of mortars, eating bowls, pestles, spoons, stools and oil pots. They are sold in a separate section of the Bangwa market, by the wives of the artisans. Unfortunately discussion of domestic art is beyond the province of this book. Carving for domestic use is not often the work of the professional carver who specialises in masks, figures and ritual objects. Professional carvers, however, do turn their hand to elaborate domestic articles used by chiefs or in societies of nobles. These include royal stools, eating bowls and decorated oil pots, illustrated in Figs 10–13 and Plate 25. The artist, rather than the craftsmen is responsible for those objects, since their success depends on their aesthetic appeal as well as their efficiency as useful objects.

THE CRAFT

Trees suitable for carving grow in the forests surrounding the more densely settled districts. Chiefs preserve such trees for specific purposes – the carving of a slit-gong or a new set of masks. When a carver needs wood for his work he approaches the chief, owner of the forest, and receives permission to fell the tree. Most of the best trees are now only found several steep miles from the villages. No payment is made to the chief: nor is there any rite to be undertaken before the tree is felled today. Once cut down the tree is left to season and taken to the compound where the carving is to be done. Hardwoods are preferred by the professional carver since they last better, resist termites and allow certain kinds of fine detail. Nowadays seasoned wood is hardly used at all and softwood is preferred by the amateur carver. The work is easier but accidents are more frequent; modern pieces frequently develop huge cracks, which the old ones rarely do.

48

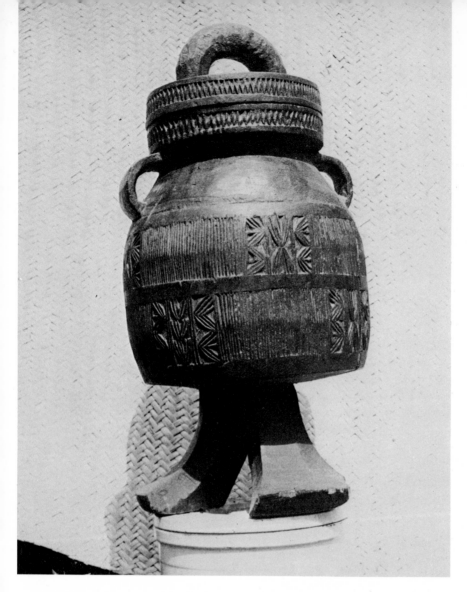

Plate 25
Oil pot

The sculptor carves consistently over the whole surface of a piece of wood, so that the piece progresses as a whole. The large block is pared down, taking grain into consideration, until the various blocks composing a figure are visible (Plate 19). Fantastic shapes appear which have no relation to the original shape of the wood. In the helmet masks of the Royal society, on the other hand, the artist makes only minor changes in the pole-shape of the original block. The rough work, including all the main shaping, is done with a cutlass, a strong, broad, one-sided knife, about two feet long. This is the universal tool of the Bangwa man and woman and is used for all farmwork, for raffia and

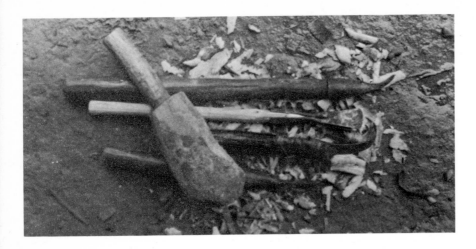

Plate 26
Carving tools

oil-palm work and for butchering meat. It is an admirable all-purpose instrument which can both fell a tree and peel a kola nut. Some cutlasses which are considered superior, are made by the local blacksmiths; others are imported. On the whole the Bangwa are content with traditional tools. Even wealthy carvers prefer them to those of European manufacture. The Bangwa sculptor has never been limited by his primitive technology. When the outline has been achieved with a cutlass, he uses a mallet and a series of curved chisels for detailing. He sometimes uses charcoal to draw in the lines to be followed. A double-handed semi-circular blade is used to empty the inside of masks and mortars.

In some of the statues associated with the ancestor cult the figure achieves strength by the crude finish of the wood. In some of the great masks of the Night society the sculptor shows a remarkable indifference to detail (Plate 27). The surface shows the grooves and chips of knife and chisel (Plate 26). This in itself differentiates many of the Night masks and ancestor figures from the finely finished masks of the Royal and Challenge societies. These masks are smoothed with a rough-textured leaf, or, nowadays, with sandpaper. There are some masks which appear to have been worked with a kind of rasp. An even smoother texture, of course, is achieved by skin-covering.

PATINA

A finished mask may be treated in several ways. The Night society masks are rubbed in oil and placed high up in the hut in the smoke of a central fire. Ancestor figures nowadays being made by the family of artists led by the head blacksmith are treated with certain leaves to give the wood an initial blackness. Palm oil is then rubbed on them, as a preservative, and they are laid in racks in a

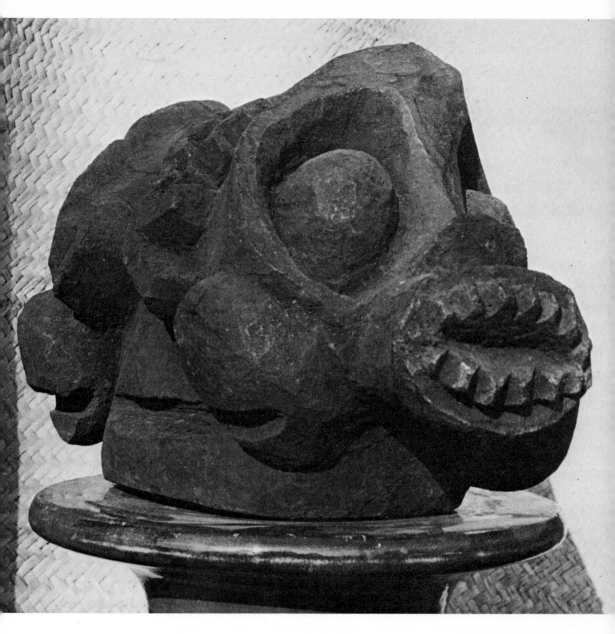

Plate 27
Double-headed Night
'mask'

51

126930

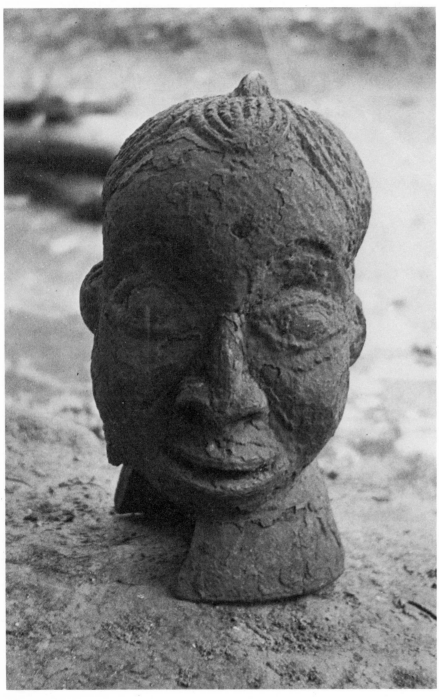

Plate 28
A Night mask with
thick patina before
cleaning

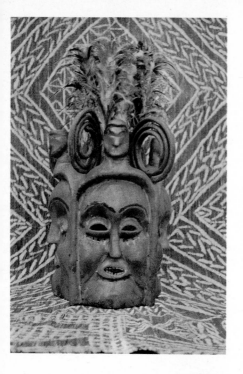

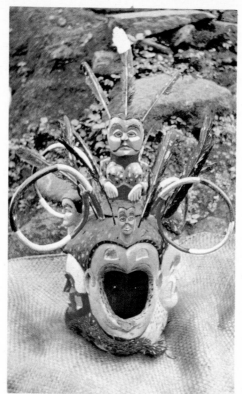

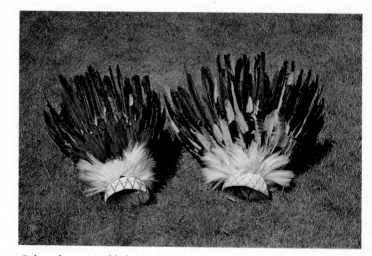

Colour plate 3 Royal helmet mask
Colour plate 4 Modern Royal mask (polychrome)
Colour plate 5 Beaded wine calabash with bird stopper
Colour plate 6 Feather head‑dresses

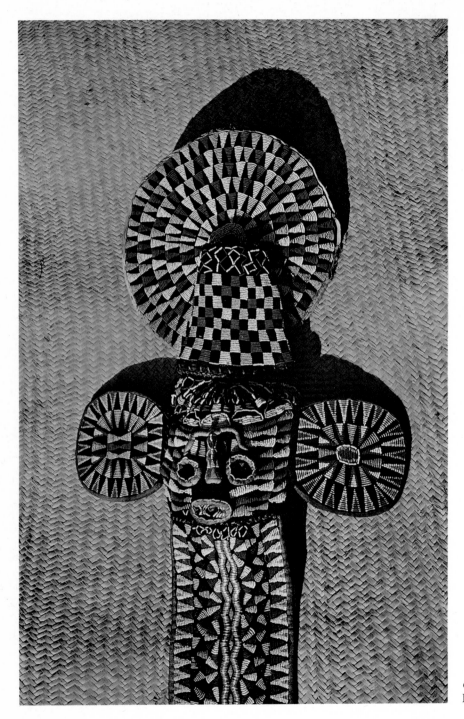

Colour plate 7
Beaded elephant mask

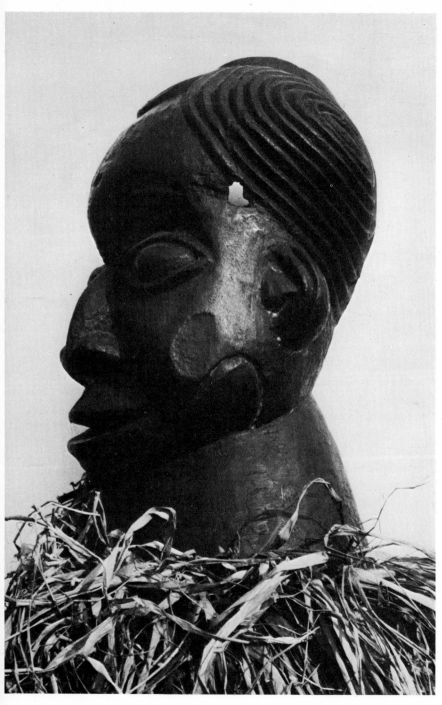

Plate 29
The same Night mask
after cleaning, with
raffia attached

special hut, a few feet over a permanently burning fire of green wood which smokes continuously. Patina is acquired through smoking and many masks are found encrusted with soot, mud and congealed blood. On the whole the sculptor does not see this as part of the aesthetic effect of the finished work of art (*pace* modern collectors who admire mysterious patina). Often parts of the decoration, even whole features of it, are entirely obscured by the dirt of months of neglect (Plate 28). On the other hand it should be pointed out that in the case of the Night society masks the thick, black patina is purposely left to make them more terrifying.

SKIN-COVERING

Skin-covering is a common process used by the Bangwa artist to achieve further textural effects. In some cases the carver himself covers the masks. In others he calls in an expert. Any pliable skin is suitable; monkey, antelope, sheep, even pig's bladder. Even Conrau, after his death, was scalped and the skin of his face worn by the then princess royal at a funeral celebration in a neighbouring chiefdom. This is the only indication that human skin might have been used for covering masks.

Skin-covering is a lengthy process. The animal is skinned with great care. The fat is removed by scraping and the skin left to soak in a running stream for several days until it becomes malleable. The hairs are removed with a knife. The skin is cut to a rough shape, and stretched wet over the mask and fastened on to the wood with small bamboo pins. It is forced into the deep cavities of the eyes and over the nose and ears. The mask is then bound with fine, plaited fibres which press the skin firmly against the wood, and left for about a week. During this time the skin hardens and moulds itself round the contours of the mask. The cord is removed, usually leaving indentations. The skin is trimmed round the eyes and mouth and sewn where it joins at the neck or back. Janus masks are given a skin to each face and joined at the sides. The smaller heads attached to large masks may also be covered. The finished mask is usually coloured red and the hairline and beard suggested with black paint. The eye rims are frequently lined with a silver metal.

Skin-covering adds a further dimension to the masks of the Royal and Challenge societies (Plates 10, 15) and the effects are strikingly successful. No mask of the Night society has been discovered with skin-covering, possibly because the inspiration of these masks is from the east and not from the western forests of the Ekoi and other Cross River tribes where the Royal and Challenge societies probably originated. In the simply shaped blocks of the Royal society masks the use of skin allows the carver an alternative technique for details. Tribal marks on the cheek or forehead need not be incorporated into the carving

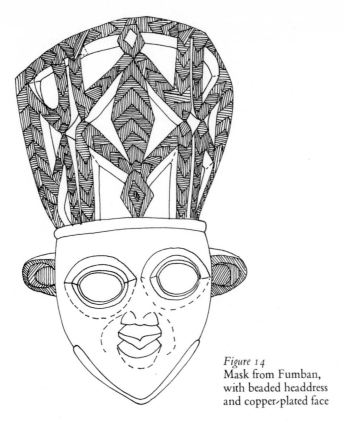

Figure 14
Mask from Fumban,
with beaded headdress
and copper-plated face

of the mask but may be added later, being fastened separately to the carving before the skin is added (Plate 10). Even whole features may be added in this way; there are old masks of the type illustrated in Plate 17 which show artificially attached protruding mouths and eyes when the skin peels away. Among the Bamileke many masks are beaded after completion by the sculptor (Fig. 14): Bangwa beadwork appears to be limited to carved fly-whisk handles, calabashes and the sewn Elephant society masks (Col. pls. 5, 7).

COLOURING AND DECORATION

Most masks (except of course the Night masks) are coloured by the addition of red or black vegetable dyes (from leaves, kola nuts or camwood barks). Both wooden and skin-covered masks are dyed. Nowadays there is a type of mask which is painted in bright polychrome (Col. pl. 4). Many masks become far more elaborate once they have left the sculptor's workshop. Dyed plumes are placed in a hole on the top. Striated horns, made from bamboo, are inserted at each corner. Cockades made from the fine hair of a ram's beard are added

55

(Col. pl. 3). Raffia is plaited and fastened to the chin in the form of a beard; or is attached to the front and back of head masks (Plate 29).

Plate 30
Newly carved drum, after medication

MEDICATION OF THE CARVING

Once the artist's work is over, the mask, statue or fetish is taken to a ritual expert to be medicated. Even drums are medicated (Plate 30). The only carvings which are considered complete once they leave the sculptor's hands are those of purely domestic use; such as dishes, stools and carved houseposts. Medication gives the objects power: it makes a drum sound well, or a mask dance well. By medication Night society masks acquire the gift of transforming members into witch shapes, and an ancestor figure becomes the repository of a piece of the soul of the ancestor. A fetish gains dangerous powers with which it can harm witches. Objects which have been medicated are honoured and

revered. They are regarded as beings and treated with exaggerated respect and are surrounded by taboos. This applies particularly to the ancestor figures, the Night masks and the fetishes. These are presented in public only after elaborate ritual precautions. They are handled by retainers, who are unpolluted by sex and by certain foods. A *kungang* fetish (see p. 127) is carried by its particular servant who walks with a leaf in his mouth (a symbol of his enforced silence and state of ritual purity) and one bare buttock revealed to enable the power of the object to escape from his body. Dance masks are medicated; henceforth they are respected for their ability to dance as well as for their beauty, but they are not considered powerful in themselves.

The Bangwa loosely call all their figures and masks 'jujus'. Ancestor figures (e.g. Fig. 15) are ritual objects but they are not fetishes. They are the temporary abodes of spirits during sacrifices. Stories are told of these statues being used as magical implements in the aggrandisement of chiefship. They may fly through the air to carry out the chief's wishes in any part of the country. In this, however, they are not much different from miraculous madonnas, which are certainly not fetishes. A fetish is an object, fashioned of wood, or any other material which has an inherent power, active at all times. Only the anti-witchcraft figures (*njoo* and *lekat*, see pp. 127 ff.) are true fetishes among the Bangwa art objects, although the association of the Night masks with the supernatural activities has given them a dreaded prestige, which is bolstered by members of the society and the chief. The 'masks' are not worn but carried; chiefs say the masks' power would kill a person who placed one on his head. But the mystique associated with these masks is part of a general aura of mystery which has been built up around this police society.

These various magical elements are added to the art object by the ritual expert. In this sense his work is considered as important as the carver's. It may convert the clumsiest effort of an amateur into a mighty fetish. Naturally, however, a statue should express, by its beauty and imposing form, the power inherent in it. The Bangwa enjoy sculpture and have high standards by which they judge it. But their enjoyment is, on the whole, the appreciation of good craftsmanship, a good likeness – not an articulate appreciation of an artist's vision. A mask is well carved; it must also dance well or efficiently protect the country. A statue may look like the dead chief, but it must also have the power to communicate with the ancestors. What is important is the proficiency of the piece in fulfilling its function; and this proficiency is determined not by aesthetics, but by its magical potential, which is given it by the ritual expert, not the carver. This is an aspect of art which is somewhat difficult for a European to grasp. It comes home to him when he tries to buy a carving. An uninspired, badly preserved mask may cost twenty times as much as a marvellously carved figure in mint condition:

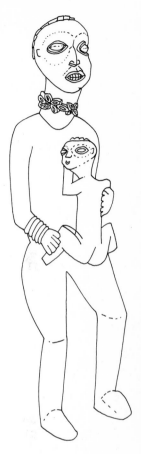

Figure 15
Ancestor figure of mother and child

57

because the former has been medicated. The buyer is buying the work of the ritual expert, and the power accumulated over time, as well as the work of the carver.

Treatment by the ritual expert (usually a *tanyi* priest, a father of twins) varies according to the object. We only witnessed the medication of a drum (Plate 30). An elaborate mixture of barks was ground, mixed with the blood of a cock and squeezed on to the carving. The most important ingredient is the bark of the *ndung* tree; which is believed to have human affinities. It screams when its bark ('skin') is removed, and its power is believed sufficient to decapitate the fowl which the owner of the drum brings in order to appease it. Drops of medicine were squeezed over the drum, accompanied by the appropriate incantations. It is blessed by the Night society of the chief and a goat is sacri-ficed on the drum itself. The type of carving determines the type of medication. The most powerful masks associated with the Night society and the fetishes receive a more elaborate and highly secret medication. It is even hinted that human sacrifice was once involved in the medicating of these masks. But it is not only masks and figures that are treated in this way.

THE CARE OF ART OBJECTS

Bangwa art objects are liable to deteriorate. The climate is wet – the rainy season lasting for up to nine months in the year. Termites are a constant threat. Even in 1967 many great masks and statues were kept out of doors, usually on a bamboo shelf built on to an outside wall. Some ancestor figures stand in lean-to skull-houses often poorly protected from the weather – the feet usually rot first. A few years is enough for a mask to suffer serious deterioration. Not one of the famous beaded *manjong* masks, in use in the 1950s, is extant today. The only Elephant beaded masks are those that have been kept in the drying smoke of a house-loft. The Bangwa house is a solid construction and offers a greater degree of protection than is usual in primitive conditions. However, they are liable to frequent fire hazards; the high thatch roofs catch alight and the fire spreads easily to neighbouring huts. For this reason many Bangwa chiefs prefer to scatter their precious sculptures and other objects among dispersed kin and retainers living outside the palace. Most chiefs who lack royal paraphernalia ('king-things' in pidgin English) blame fires of this kind. Chief Fontem and other paramount chiefs blame the harsh reprisals which were inflicted on them at the conclusion of the Bangwa uprising against the Germans in the 1900s when most of the large palaces were then sacked and burned.

Most masks are stored in lofts today; when they are finally brought out at the request of an inquisitive anthropologist their condition is often very bad. Masks of the Night society and Gong society figures are kept in a secret place

and are not used very frequently. They may be forgotten for years on end. On the whole masks which are in constant use, such as the dance masks which appear at cry-dies of commoners, remain in a reasonable state. They are kept in a dry place, above a constantly tended fire. Some old masks have lasted particularly well, preserved by layers of smoke and soot. The skin-covered masks are not allowed to collect the kind of black patina which adds wonder to the Night society masks, but they are oiled and cleaned in a more or less regular fashion. They are taken out into the courtyard during brief spells of sunshine during the rainy season. The masks of the Night society, on the other hand, are rarely touched and must on no account be cleaned, though they may be repaired. Cracks are filled with beeswax and prevented from widening with strong vine-rope clips. Once an art object no longer has a use or aesthetic interest it is thrown out and replaced by an object that has. And if something rots there are sculptors to replace it.

INDIVIDUAL STYLES

Although the sculptor is to a certain extent limited by traditional styles there are many opportunities for individual expression. The Bangwa sculptor was not working simply to satisfy ritual functions. Many other objects apart from masks and portrait figures are made and ornamented according to the artist's or patron's fancy. Eating bowls are decorated with prancing leopards; the tail of a dog forms the rim of a wooden plate; naked women support a camwood bowl; wooden houseposts with innumerable figures give the sculptor scope for invention; fly-whisk handles are made in a multitude of shapes. The use of paraphernalia is not rigidly fixed; new ideas and foreign paints and ornaments may be added without upsetting traditions. In fact, in cases such as these, the more original the more wondrous they are. A carved antelope's head bought by the authors in Fumban, a different culture a hundred miles away, performed with great success at one cry; one of the women's societies received applause when one of their number wore a large pink wax doll on her head. A present of a Guardsman's bearskin was incorporated with no difficulty.

The Bangwa carver expresses his own vision within a traditional framework. Rarely are the works of famous carvers merely copied by their apprentices; nor does an artist sit down to re-create a work that has already proved its rigid ritual efficiency. Although the type of mask may be similar no mask is ever an exact copy, except in the case of the very new tourist models. Once a man has developed his own treatment of ancestor figures or Night masks he may carve several which are of the same general form, but they are never identical (see Plate 14). There is a kind of stylistic progression, a weaving backwards and forwards around a central model. The symbolism required for the efficacy of a mask or

figure is respected. An ancestor memorial gives an imposing portrayal of a chief in full regalia; a fetish must have the swollen stomach and bent knees of the afflicted witch; a Night mask should be awesome. But within this traditional symbolic framework the artist develops his own individual ideals, minimising or stressing certain features, adding or removing details as he feels inclined. In the masks even single features receive different approaches according to the needs of the mask-type, or according to the fancy of the artist. Ears, for instance, can be little oblong lumps, striated triangles, or curved peaks (see pp. 131–44). Eyes may be incised circles, triangular hollows, huge windows, egg-shaped, bulging, or cylindrical. The mouth may be closed, wide-open, with or without teeth, laughing or serious. Masks may be painted, skin-covered, decorated with raffia or with feathers, or fur – or left in a natural state.

CHANGING STANDARDS AND MODERN SCULPTURE

Western art critics declare that the Bangwa have achieved masterpieces of sculpture. Judging Bangwa art is not easy, for their standards are not necessarily our own. It is difficult for foreign experts to discriminate between good sculpture and poor imitation. It is rare for the poorest Bangwa figure or mask to lack vigour; yet it is possible to make a comparative assessment of their aesthetic value and of the craftsmanship of the sculptor. Some Bangwa pieces in European museums are no more distinguished than rough-hewn carvings made by youths to pass away a few minutes. Inferior ideas and inferior execution are noticed by Bangwa experts. A comparison of Plates 31 and 32 on p. 61 is illuminating. Plate 32 is not a new sculpture nor an example of contemporary decline but a highly valued old work. Nevertheless it can be seen to be badly carved, with its flattened nose, a drinking horn crudely attached to its chin, and an improbable jaw line. This is not an example of primitive liveliness, stylisation or inventiveness, but of uncertain, unskilled workmanship.

Poor modern work is made of unseasoned wood so that cracks abound and the extremities drop off with the slightest accident. Lack of symmetry is accidental. These figures, carved in response to a demand for old statues are given an entirely frontal position and are stiff and lifeless as a result (Plate 33). And the same lifelessness also invades the work of professional carvers working on subjects of which they have little experience. Most of them are bewildered when their work is rejected. They believe that this is because the European wants 'antiques' and so rows of identical Night masks and ancestor figures are rubbed in oil and soot and smoked above fires and turned into heirlooms for the unwary buyer.

The problem of a comparative study of new and old work is made more difficult by the fact that until 1966 and 1967 no Night masks or ancestor memorials had been made for many years. Nowadays they are being made by amateurs

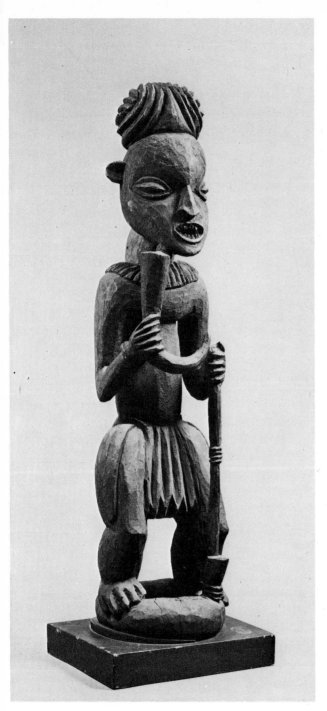

Plate 31
Royal ancestor figure

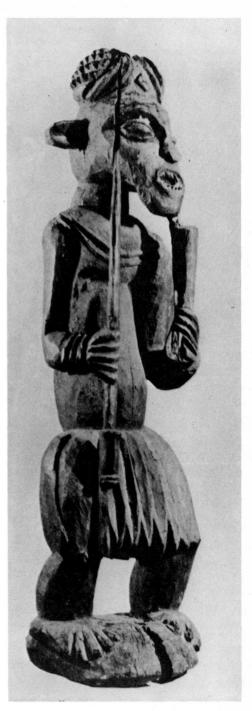

Plate 32
Royal ancestor figure

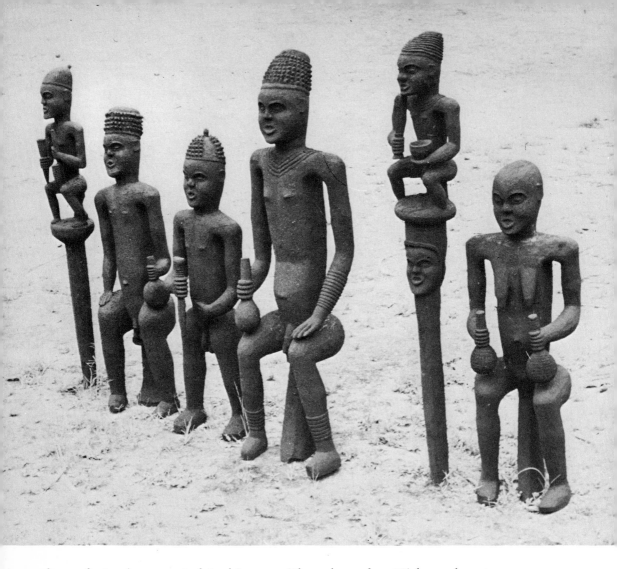

or by professionals unpractised in this genre. The only modern Night mask illustrated in this book was made to satisfy the interest of the authors (Plate 21). Today, spurred on by a recent European interest in their work, everyone, trained or not, is chip-chipping away, copying a Night mask, or an ancestral figure. Even the professional works as fast as possible since the prices given cannot compare with those paid by wealthy chiefs in the past. A statue used to take several months to complete. Now a carver spends less than a week. Older men know that these rough and ready methods must detract from the perfection of the work. They say that it used to take twenty years of apprenticeship before a sculptor could or should tackle an ancestor figure, and that a Night society mask should not be attempted with any chance of success until a carver had

Plate 33
Modern figures made by the Blacksmith group for the tourist trade

62

both a daughter and a son. The total commitment of the old masters included abstinence from sex and certain foods throughout the period of work. Modern carvings, say the elders, cannot compare with the inspired work of the past.

If neither the sculptor, nor his patrons, believe in shape-changing, the magical powers of the chiefs, the supernatural potential of twin-mothers or the benefits derived from the ancestors and the mystical depradations of the Night society, then the objects themselves cease to communicate to the audience. On the other hand, until the carvers were spurred to copy, unsuccessfully, portraits and Night masks for Europeans, they were content to carve sculpture which still retained meaning in the Bangwa of the 1960s and for which there is a constant public. These are the masks associated with the dance societies to which not the chiefs, but the young men, who have the money, belong. Anti-witchcraft fetishes are still in demand: witchcraft is one of the beliefs which are still strong. The young are not concerned with old things for their own sake. Many of them took the missionaries' advice and threw out their 'idols'. A number of remarkable ancestor figures have been found lying in the bush, in deserted compounds (Col. pl. 1). The real need for them has gone. The arrival of primitive art experts from Europe to buy only the *old* carvings cannot stimulate what is already dead.

There are few masterpieces left in Bangwa. The first reaction to requests by traders, representing European collectors, was to shout in indignation: 'How can I sell my grandfather? What will happen to the country if we sell the symbols of the Night society?' Yet the rising tide of scepticism towards the old cults, encouraged by missionaries and converted youths, persuaded the chiefs and heads of kin groups to sell the carvings. Only a few diehards have been able to resist the blandishments of the traders, who offer them up to £300 for a figure. The sale is easily rationalised: 'Why should we keep the dirty old things, lying in the loft, rotting in the damp?' They are therefore sold. A modern chief needs money to send his children to school and buy a Land-Rover. Some of the figures are replaced by new ones, which are placed in the skull-house. Since most of these sculptures only appear in public at rare intervals most people will be unaware of the change. Masks of the Night society belong not to the society, but to the country as a whole; ancestral figures (Fig. 16) belong to the family, not to the chief alone. The sale of a famous Bangwa figure in 1967 occasioned a public outcry, not because it was sold but because it was sold without consulting the corporate group of owners. Some chiefs cover themselves by first consulting the ancestors, through the figures they wish to sell and the skulls. Food is offered to them, and if it is eaten by them (by the termites) this is taken as a sign that the ancestors agree to the sale. An eager seller can, of course, repeat the sacrifice until the termites give him the correct answer. The chiefs further justify the sale of the

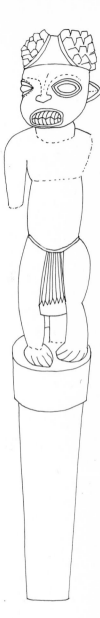

Figure 16
Ancestor figure

63

masks by saying that it is not the mask itself which is important, but the medica-
tion. A new mask can go through the same treatment and receive the same
mystical powers. However an ancestor figure was originally carved as a portrait
of an individual; a copy by a contemporary sculptor is not the same. And as
Chief Fontem points out the medication performed by present-day ritual
experts is not of the same order as in olden days. To many Bangwa what the
European is buying is not an object of aesthetic interest; they do not believe that a
Night mask is really going to sit in a museum for people to stare at. For them
the huge prices are being paid for their supernatural powers, which the ancient
ritual experts gave them and which will be used to their advantage by the
Europeans. There has been a reaction against the wholesale selling of the masks
and figures. Chief Fontem sent off his retainers to the compounds of his sub-
chiefs and nobles to check periodically that the full complement of Gong and
Night society paraphernalia is still there. The sale of a famous figure by a chief's
brother occasioned a public outcry and several weeks' discussions and meetings.
The man was fined, ostracised and told to arrange for the replacement of the
carving. He did so, the new carving costing him £15. The old one was sold for
£100. In a New York sale-room it may fetch up to £10,000.

CHAPTER FOUR

The cry-die

This chapter describes in some detail the funeral of a chief and the crowning of his heir. It is on these occasions that art objects are brought out for use and public displays, providing the most concentrated presentation of the emblems associated with chiefship, secret societies and dance associations. These rites and celebra-tions are known in pidgin English as a cry-die or in Bangwa as the 'death' (*legwü*). A cry celebrates both the transition of the dead chief's spirit into the ancestor world and the succession of his heir to his earthly status. At a cry a man is mourned by his relatives, subjects and peers. The cry is theoretically the responsibility of the successor: by carrying out these rites in honour of his father's memory he earns the right to assume his new status. Over a period of several days he entertains his father's friends and kin, who provide masquerades, dances and performances of warrior and cult associations to entertain the assembled mourners. In the case of a commoner the funeral may be delayed while the heir husbands sufficient resources to provide a splendid feast; in the case of a chief delay would be dangerous, since a long interregnum may involve the country in bitter succession disputes.

In many ways the cry is a theatrical performance rather than a rite. The sacred nature of the ceremony is hardly obvious to a casual observer. The ritual is carried out by a few experts in secret. To the majority of spectators the funeral is an excuse to eat, drink and be merry. The burden of mourning is borne by a man's close kin, his widows and children. A chief's subjects come to honour him, but also to be entertained by the performances of the jujus and to join in

the dancing themselves. As far as the majority of the people are concerned the success of a cry is determined by the amount of food and wine they can consume and the splendour and vigour of the dancing. But throughout the ceremony the bitter wailing of the naked, mud-spattered widows makes a strange contrast with the revels of the crowd, who, equipped with drum and xylophone, painted mask and bright cloths, dance and sing around this mourning group, the only 'funereal' aspect of the celebrations.

The public aspect of a typical cry involves performances by various societies, whose dancing, masks and costumes make or mar the success of the mortuary rite. Cult associations and dance societies from the palace perform. Fellow-chiefs, sons-in-law and subjects organise their own masquerades; the same dance may be performed by several groups and there is a great deal of competition over masks, costumes, music and dancing. The brilliance of a man's society is a sign of his wealth and rank, for a rich man buys dance societies and cult associations in the same way that he buys fine clothes, furniture and wives. In many cases the original functions of the society have lapsed; the performances have become mere spectacles. Thus the headhunting group, Challenge, is today no more than an *ad hoc* dance group with associated masks. *Manjong*, formerly a national association of young warriors, meets to dance and feast.

Political associations which lose their *raison d'être* die natural deaths. The Night society, for example, no longer hangs witches or administers the poison ordeal; but it has an important role at the cry. In many cases older Bangwa societies are dying out and being replaced by new societies with new dances, new masks. *Massem* is a recent acquisition from the south; the Leopard society comes from south-eastern Nigeria via the Ekoi and Banyang. On the whole modern Bangwa are looking away from the grasslands to the forest for inspiration. Young men club together to buy democratic jujus from their forest neighbours the Banyang. Even women have begun to form their own societies and to commission masks. The chiefs in Bangwa are ceasing to monopolise this aspect of social life; even nobles are beginning to lapse as members of the traditional societies and to join with commoners in the new forest societies.

A cry is also a framework for highly involved economic transactions. Although the cost of the entertainment is borne primarily by the dead man's immediate family, the successor receives support from other kinsfolk, subjects, and, particularly, affines. Nobody comes to a cry empty-handed. Food brought by mourners is redistributed to those present in the temporary kitchens. The societies which attend and provide the entertainment receive customary payments according to the rank held by the dead man in the society. Payments are also made to the chief's successor, by subchiefs and other nobles. As far as the greater chiefs are concerned a cry may even make a profit. Sons-in-law and male

and female marriage wards (see p. 19) make fixed contributions enforceable in the native courts. The sums vary from £2 for a commoner male ward to over £10 for a royal ward; they usually include a 'skin of death', formerly a goatskin, now a length of imported cloth. The chief's scribe writes these down and defaulters at the end of the cry are sued.

The people primarily concerned with a chief's death and burial are the Nine, the inner sanctum of the Night society, to whom the chief confides the name of his successor. When he dies his death is not announced publicly. The Night society places its emblems outside the door of his hut, to keep unwelcome visitors away as they prepare for the burial. The widows are not told of the death. The princess royal, a member of the Night society, informs them that their husband's condition is steadily improving. Everyone fears the palace riots that may ensue if a wealthy man's widows and their sons learn that he is dead before his successor is installed. The burial is carried out immediately by the Nine.

The corpse is anointed by the heir with medicines prepared by a priest of the earth (*tanyi*, see p. 124). If the chief dies young, witchcraft is suspected and an autopsy follows, the cause of death being ascertained by a diviner who performs an autopsy. The body is buried in a Night society cloth made of plantain fibre, with a live white cock tied to the right hand and a khaki-coloured bead (*akyet*) in each nostril (Plate 34). It is buried on its side facing east. Night society members fill in the oblong grave, leaving a section incomplete for a secondary, symbolic burial which takes place when the Night society of the chief's marriage lord (*tangkap*, see p. 19) performs an important rite during the ensuing public funeral rites. A sapling (of the same plant carried by *tanyi* and mothers of twins) is planted above the dead man's head to indicate its position when sacrifices are made, and, later, when the skull is to be exhumed so that it can be placed in the royal skull-house.

Preparations now go ahead for the public cry. Messages are sent to neighbouring chiefs, kinsfolk of the late chief and his successor, and important ritual experts. A fiction that the chief is alive, however, is still maintained. The widows bring food to his sleeping hut; the princess royal talks of his 'health' in the market. All this time preparations for the cry go on, both inside the palace and in the compounds of subchiefs and nobles who will bring a dance or cult association to mourn their chief and entertain the public. The late chief has made his own preparations before his death, since a Bangwa man is very concerned that his success when alive should be reflected in the splendour of his funeral rites. Money has been set aside in his will for buying meat and wine. Masks, drums, xylophones and costumes have been commissioned and put by – often for years – for this day. His friends and retainers have been given elaborate instructions for the organising of the ceremonies, and informed how the performances of

67

the palace societies should be presented and what monies and foodstuffs should be given to visiting troupes. Most important, he has had his portrait carved (Plate 31) a full figure wearing royal ornaments, which will be placed alongside those of his ancestors in the skull-house. During the cry this portrait will appear in the sacred copse near the palace where the Gong society performs. In fact, chiefs and nobles no longer commission these figures except in isolated cases. There are, however, many extant and appear during the annual performances of the royal Gong society (see p. 82).

The palace retainers bring out the royal paraphernalia. Although some of the masks, statues and costumes are newly made for the cry, others need repair. Some of the objects, such as the Night society masks, may not have seen the light of day for years. Inevitably some have disintegrated through damp and neglect. Others are repainted, oiled or polished. Special attention is paid to those precious objects associated with the chiefship. A visit to any Bangwa chief usually includes a private view of these 'king-things'. They include horsetail-whisks, beaded calabashes, odd carvings, mighty ivory bracelets, drinking horns of the royal dwarf cow, lengths of blue and white patterned cloth, and so on. There is usually also a miscellaneous collection of European objects hoarded since early slaving days or received as gifts from colonial officers. Chiefs climb rickety ladders into the blackest depths of a high loft to show visitors an elaborate collection of Toby jugs and commemorative coronation mugs. Chief Fontem still preserves the first glass jug which was brought to Bangwa by traders and sold to the palace for seven slaves. All these things are brought out for public display during a cry. Special utensils (elaborately carved eating bowls and beaded calabashes) (Col. pl. 5; Fig. 13) are taken to the sacred copse where members of the Gong society will eat and drink. The other symbols of royal wealth and power are placed on display in front of the pavilion ready for the visiting chiefs. Leopard skins are spread on the ground, flanked by carved and uncarved ivory tusks. King-things are not only the prerogative of kings; for lesser nobles may also have their collections, some of which include objects of great beauty.

The palace begins to take on a festive air as the houses are repaired and decorated for the cry. Even now nobody may say, 'The chief is dead.' Sons-in-law and retainers do most of the work, but children cut the grass on the vast dancing field before the palace. Kitchens are built behind the wives' houses. Lengths of royal cloth are hung about the walls of the palace (Plate 35) and temporary pavilions are built around the dancing field to shelter distinguished visitors and local notables. Flags of the defunct colonial power and the newly independent state hang side by side. Stools and chairs are draped with animal skins and bright cloth from Nigeria. The paths are decorated with palm fronds

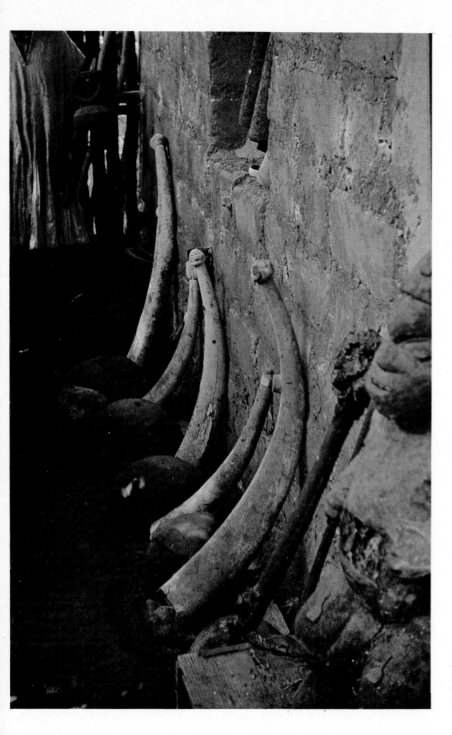

Colour plate 8
Royal shrine: ancestor
skulls are under the pots:
note oliphants and carved
figure

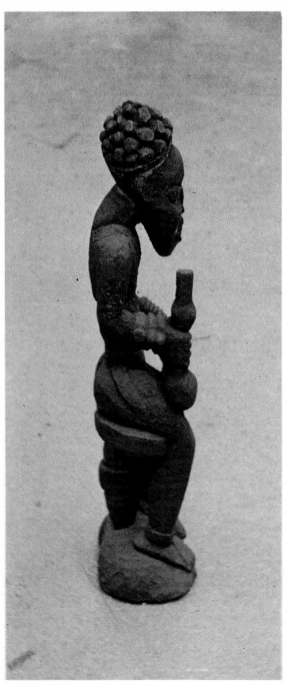

Colour plate 9
Royal ancestor statue

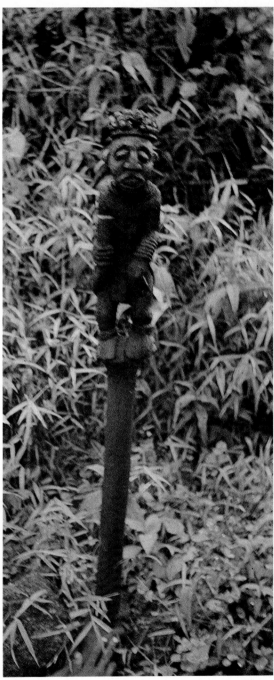

Colour plate 10
Ancestor statue outside the *lefem* copse

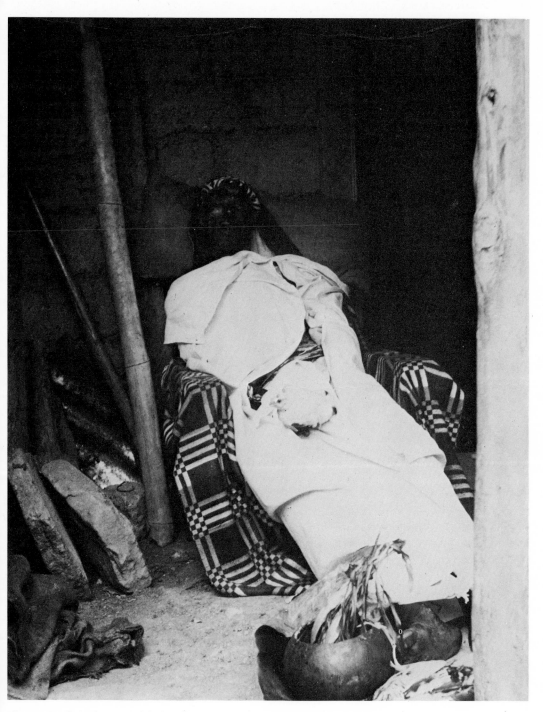

Plate 34 Dead chief, prepared for burial

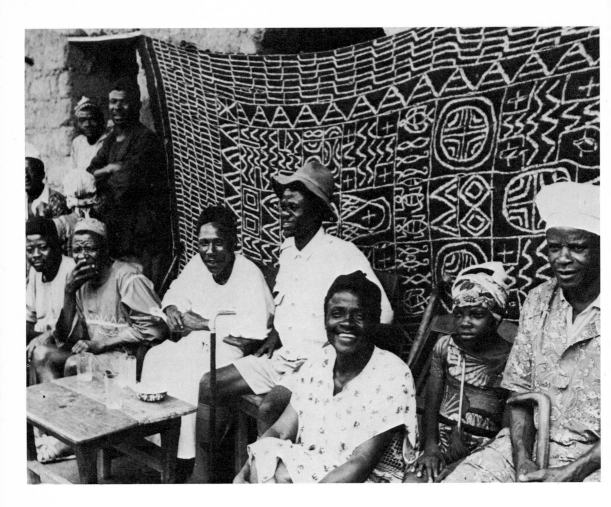

Plate 35
Group of subchiefs
at a cry

and flowers from the forest. The services of a ritual expert who knows how to prevent inclement weather are secured. The compound is also medicated against evil by members of the anti-witchcraft *kungang* society whose medicine is buried at all crossroads to prevent evil forces entering the palace district during the vital mourning and installation rites. A fetish statue (Plate 12) associated with *kungang* is installed by an expert in a corner of the field which guards against witchcraft and minor troubles such as theft that are likely to occur during the cry.

At dawn, on the first day of the cry, the country rings out with resounding drumming from one of the vast slit-gongs in the market-place. The Bangwa hills suddenly come alive. From early morning, in the mists arising from the forests 2,000 feet below, processions make their way along the narrow, tree-

lined path towards the palace. They are loaded with supplies of food, smoked game, fish, yams and cocoyams and other prepared delicacies. Some drag along squealing pigs, holding up the line on the track as the fat beasts are heaved bodily over the innumerable stiles. Others carry odd-shaped bundles containing dancing masks, feather head-dresses and best clothes. All paths converge on the market-place above the palace and dancing green. In Bangwa the paths are so contrived that they wind up and down steep slopes to meet at a point above an important man's compound; and a conspicuous descent is made to the flattened dance area in which the great meeting-house stands. Nobody can approach a Bangwa compound without the knowledge of its owner; nor with any great speed, since the path is usually cut into a vertical laterite bank which becomes dangerously slippery in the wet season and crumbly in the dry. On either side of the path is a green wall of palms, trees and steep cocoyam gardens studded with huge boulders. A small hut about two feet high flanks the path, the shrine of the chief's guardian spirit (*ndem bo*) which provides protection for the palace against general misfortune. Two mono-liths, the most important symbols of the country, are embedded in the earth at the bottom of the path. The powers of the chief as a ruler and a sacred being are intimately involved with these stones. Sacrifices are made here before he embarks on witchcraft tours with the Nine. During his absence from the country these stones are believed to grow towering over the palace, sheltering the inhabitants while their lord is away.

Most of the mourners stand about in the dancing field. Relatives and local nobles find their way to the hut of a widow or a palace retainer. Neighbouring chiefs are accommodated in the meeting-house (*lemoo*) (Plate 4) where they are entertained until the ceremony begins. Outside, people stand about gossip-ing, watching the new arrivals and commenting on their costumes and the quantity of their cry gifts. Nobles arrive in state (Col. pl. 13), with servants or children carrying their accoutrements. A favourite wife walks behind her hus-band bearing his stool. Old men arrive in velvet gowns and old-fashioned long-tailed embroidered caps. There are sophisticated young men in perfectly creased trousers, sun-glasses and big straw hats stuck with feathers. There are young wives in freshly laundered clothes, with freshly oiled babies bound on their backs. The spectators themselves provide a good deal of colour and spectacle. In the past such an abundance of colourful cloth was absent. Women wore no clothes apart from a waist string and carried a small bag which would be held in front of the pudenda. Cicatrisation was common, on both face and body. Elaborate hairstyles were worn by men, though not by women, the most common consisting of two peaks parted in the middle. Women mostly shaved their heads, though titled women (a princess royal, or a mother of twins) were

permitted more elaborate coiffures. For dancing the body is oiled. Men and women wear a variety of imported and local ornaments. Royal wives wear anklets of brass, the wives of lesser nobles wristlets. Mothers of twins wear cowrie necklaces or beaded torques; retainers in the service of the chief wear necklaces of dogs' or leopards' teeth.

THE OPENING OF THE CRY

The first day of the cry is given over to public mourning, the official burial of the dead chief and the crowning of the heir. The formal announcement of the chief's death is made by a short ritual performed by the palace Night society in conjunction with the Night society of the late man's marriage lord (his *tangkap*). Retainers circulate among the crowd, quietening noisy youths with threatening gestures. The chiefs and nobles leave the meeting-house and take their place in the decorated pavilions. Then, winding down the steep path comes a procession of Night maskers – flapping, stick-tapping, silent figures (Plate 36). The Night society of the dead chief's marriage lord enters the field first. They are dressed in voluminous gowns of hessian, their faces covered in blackened, knotted nets. Their appearance is awesome. They all carry long blackened sticks (Plate 37) some in fantastic shapes. Pinned on their masked heads are circlets of bamboo with large pale-green leaves which flop backwards and forwards as they lope

Plate 36
The Night society maskers 'open' the cry

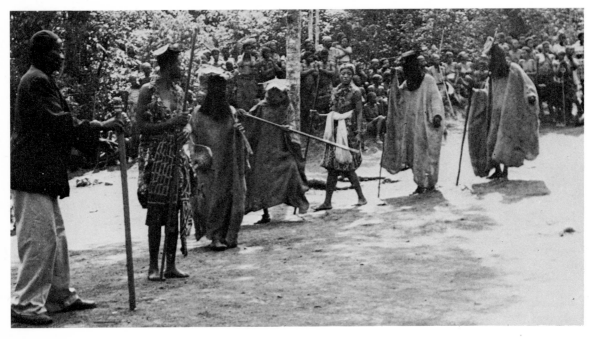

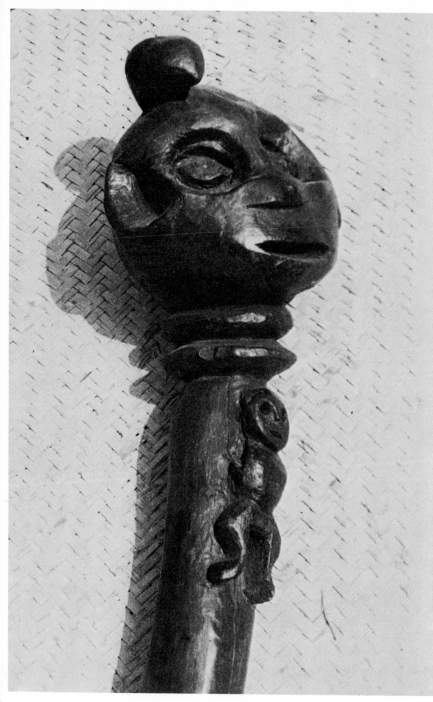

Plate 37
'Night' staff

round the field. Children run to hide. The Lord of the Night society himself wears ordinary clothes and his head is uncovered ('We are not hanging witches today; the people should know who I am.'). On his shoulder he carries one of the society's masks (Plate 21). A young man, at the end of the flapping figures, drags along an unwilling ram, its mouth bound with leaves and twine to prevent it bleating. The Night society of the late chief's marriage lord is then joined by members of his own palace Night society. They form a close-knit circle and gather round the ram.

As the masked group huddles round the ram there is still no sign from the spectators. They watch silently as the Lord of the Night takes a terror mask (Plate 8), and places it at the door of a hut which has been set aside for the use of the Night members during the cry. He returns to the field and joins the figures round the ram. They all begin to beat the ram with their sticks and the gag is removed from its mouth. A terrified bleat breaks the silence in the palace and the ram bolts from the field. A second later the bleat is answered by the noise of a gun-shot from the heart of the palace. A retainer begins to beat the huge slit-gong in the market. The cry has begun.

The widows shuffle on to the field wailing (Plate 38); their faces are daubed with mud and they carry small baskets with yams, corn and groundnuts speared on strips of bamboo. People swarm on to the field round the half-naked women who form a circle, winding round the field between the skipping, hooting members of the Night society. The Night members flick the old chief's garments into the air. They act as buffoons, their altered accents competing with the dirges of the widows. Their skipping, loping dance contrasts strangely with the sad shuffle of the mud-stained mourners. The Night society members bury the chief and crown his successor; but they are not affected by the seriousness of the occasion. They are out to enjoy themselves, to eat and drink and dance. The people's attitude to the Night society is ambivalent. At first they are fearful; later as the cry develops they begin to joke with the masked figures, attempting to imitate their disguised voices and teasing them with offers of money or choice pieces of meat. Their presence adds a cathartic element.

The dirges continue. An old retainer begins to beat out a monotonous rhythm on a large double gong. The princess royal, the late chief's sister, naked apart from a loincloth and wearing the leaves of the Night society in her hair and vines around her breast, starts singing. Her tear-stained face is daubed with camwood, a symbol of the fact that the chief died naturally and was not a witch. She wears the porcupine hat which belonged to her father. Out of the sound of hundreds of shuffling feet and rending sobs rises a wonderful mourning song, which at first is sung by the princess royal alone, and then is taken up by the whole crowd. It is a simple melody in descending semitones, with subtle

74

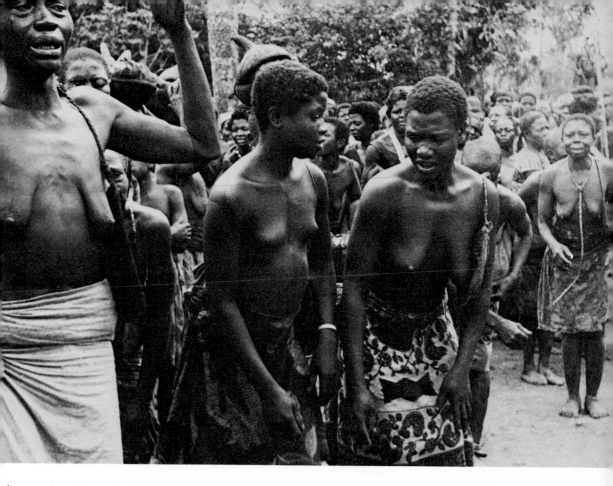

harmonies. There is a feeling of profound sadness in the song which, for a moment, communicates itself even to the huge crowd of onlookers. Over this chorus, in counterpoint, comes another song in quicker time; an old blind retainer, holding one of the widows, sings an encomium of his dead master:

'He is gone;
He is gone.
Where is he now?
He was our lord and benefactor.
He is gone.
He is gone.
He gave us food and oil.
Perhaps he has gone to give his wisdom in the courthouse.
Is he in the farm?
He is gone.
He is gone.'

75

When this singer finishes, another takes it up and merges it into a new song of remembrance. The Night maskers leave the field. Gradually only the widows and close female relatives are left. A favourite daughter makes a special show of sorrow in a corner of the field. A widow cries with abandon. Supported by other women, who try to calm her, she clutches some relic of the dead man, scratching her face. Her tears seem the most terrible of all. She wails that she would join the corpse in the grave if she could. Somebody whispers that she must be the mother of the heir, since she is mourning so wildly. When she becomes exhausted an old widow takes her place in the centre of the field, sometimes singing, sometimes weeping. Men wail too but briefly, and retire to their alcoves to chew a kola nut and await developments.

Meanwhile the members of the two Night societies are in the courtyard behind the chief's sleeping hut, performing the simple ceremony of ritually 'burying' the chief. They cluster round the grave. A cock is brought and waved three times across the faces of the masked men. Earth is placed in the hole. A plantain stem is brought and a masked member thumps the earth above the corpse's head. Suddenly there is an unearthly crash. It is the Night society's iron rattle, a series of clappers on an iron ring (Plate 39). It is a sober reminder that the feared Night society is responsible for the burial of the chief, the crowning of his successor and for continuity in this period of flux which is the royal interregnum. This rattle, known as the 'lions of the Night', is the most fearful of all the emblems of the society. Contact by an uninitiate means instant death. After this short rite the members retire to their house, at the door of which stands the terror mask. They rest – eating and drinking in private – before returning to the field for the 'snatching of the successor'. All the time the maskers exchange crude jokes in raucous accents. Inside their house they maintain their strange behaviour: they may not wash their hands before eating (the Bangwa are meticulous about this normally), nor do they eat out of bowls or use spoons or knives.

The field is empty except for the circle of widows, who dance in a slow swaying motion before the crowd. Occasionally a widow is joined by a kinsman who sings a short, plaintive cry-song, his arm round her shoulders. The princess royal arranges for an old royal kinswoman to rub oil on the widows' legs. A post has been erected in the middle of the field; standing next to it is a widow who shakes a pair of seed rattles and leads the singing. The Bangwa believe that only widows who are innocent of adultery can dance round this post during their husband's cry without incurring mystical danger. If the chief was very old when he died, elders say it is unfair to expect the widows to undergo this ordeal. A few old ladies dance with pride in the centre of the circle. The rest dance to one side, a hooting and skipping Night masker moving in and

Plate 39 The Night rattle, the 'lions of the Night'

out of their group. A tall, half-naked man then dances on to the field, brandishing a copper rod with medicine tied on to one end; he stands still and calls out to the heavens not to send rain on this great day.

SNATCHING THE NEW CHIEF

Several hours after the beginning of the cry the dancing field is cleared again. The children of the dead chief are grouped together by palace retainers: from them the Lord of the Night will 'snatch' the new chief and his titled brothers and sisters. The palace Night maskers now have the area to themselves. One of them has 'the loins of the Night' beneath his robe. They line up across the field and the skipping dance begins again. They cross the field nine times; whilst at intervals the wearer of the ring of clappers allows them to reverberate in the silence. The effect is mysterious in the electric atmosphere. When it is over they rush at the royal children, shouting in their raucous accents: 'When a chief is dead, we must have a new one!' They throw down their sticks and pull a young man from the crowd, the heir. He is immediately hounded round the field, the masked figures beating him with their fists and sticks. 'This is the last time you will be beaten; that is why we are doing it now.' They send him off to the house of the Night with one masker. Then they turn back to the royal children and snatch two girls and two boys, each of whom is to succeed to a royal title. Two young women, preferably betrothed virgins, are also pulled out of the group of weeping widows. They retire to the Night hut where the chief and his brothers and sisters are wrapped in royal cloth (Plate 40) in order to be briefly presented to the people. Led by the Lord of the Night they dance with the widows and mourning kin for a few minutes before returning to the palace.

As the widows stream around the dancing field, swaying and weeping, a retainer carries a carved oil-pot (Fig. 17) and places it in the middle of the arena. The princess royal dips her hand into the oil and anoints the feet and legs of each of the widows. This is done, she tells them, to prevent their late husband's oil-palms from drying up and to prevent the women of the country from becoming barren. Then the Lord of the Night society of the late chief's marriage lord (*tangkap*) returns to the mourning field and with a sharp knife cuts the beaded string which is tied round the waist of each widow. On each waistband the widows have tied a coin which becomes the property of the delighted Night members. Without their waist strings the widows are now 'naked'. Cutting this string is an initial gesture in separating the women from their late husband; the ritual culminates in the lustration of the widows in the river at the end of the cry in nine weeks' time.

Figure 17
Oil container

78

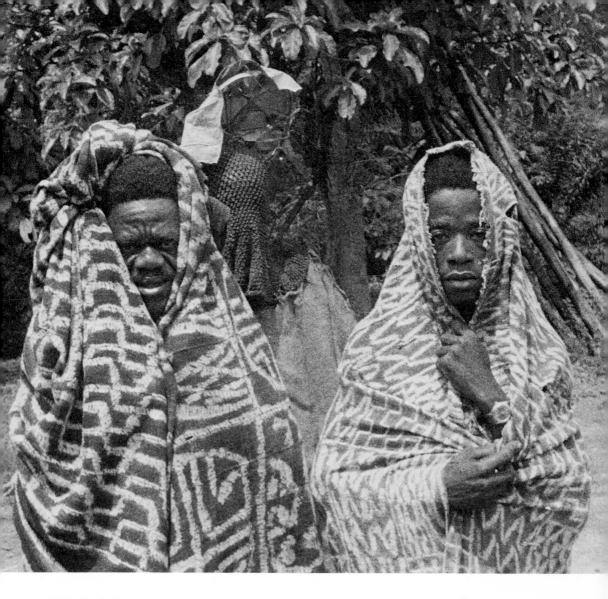

THE ENTHRONING

While the general singing and weeping continues the new chief and his brothers and sisters are enthroned. The chief is crowned in his father's sleeping-hut, in the heart of the palace, at the end of a series of courtyards formed by the red-mudded walls of the other huts and high fern pole screens. The house has not been changed since the chief's death. Inside and out, the walls are smothered with odd pieces of paper: newspaper cuttings, envelopes and photographs. There are maps of the 'Gold Coast' and 'Southern Cameroons', reminders of the colonial past. There is a picture of a district officer with the late chief in

Plate 40
The chief and his brother in Royal cloth during the enthroning rites

79

Mamfe surrounded by the members of his German brass band, a few wives and his dog, celebrating Empire Day. There are faded photographs of George VI and Winston Churchill. In another photograph the chief is shown with the Lord of the Night society dressed in an old-fashioned loincloth and a small naked boy holding a gun. This boy is now the young man waiting nervously in the windowless room. The photograph was taken by the district officer many years ago as proof that this boy was the chief's chosen successor. The old princess royal motions to the chief-elect to take off his clothes. She places a leopard skin over a large carved stool, the royal stool, on which only a chief may sit (Plate 41). The young brothers and sisters who are succeeding to minor titles stand back against the wall. This ceremony mainly concerns the chief. Dressed only in a loincloth he stands before the Night members. The priest of the earth (*tanyi*) takes bundles of herbs and medicines from his bag and sorts them into piles. He takes one, hands it to the young man, who holds the bundle fast while the Lord of the Night breaks off nine pieces. The new princess royal is called across to tear off three pieces. The priest places them on the grindstone, together with powdered barks, bones and a sacred white powder which has been taken from a bamboo phial in the late chief's own bag. A white cock is brought and nine drops extracted from its claw are made to drip on the mixture being ground by the old princess royal. A ram, kicking and bleeding, is dragged into the hut and two members of the Night society hold it while the priest of the earth cuts its throat. The blood is preserved in a bowl; the meat will be eaten by the kingmakers later. After a long process the medicine is prepared; to it is added the blood, the medicine which was rubbed on the dead chief before burial and the heart of a cock. The princess royal divides it into two parts: one for eating, the other for anointing. The chief and his brothers are given it in their hands and told carefully to lick it off. 'Now you have eaten this medicine all fear shall leave you.' The Lord of the Night places his right toe in the anointing mixture and, making the chief squat down, traces with it a line from the boy's shoulder to his buttocks, saying: 'When you shout, let people fear. These leaves and medicines will give you power. Whenever you shout people will fear. The only people you need fear now are the country's gods.' The 'loins of the Night', the ring of clappers (Plate 39) is brought and smeared with the mixture. It is rubbed up and down the chests and backs of the new chief and his two brothers. The remains of the mixture are kept for the chief to use during the next nine weeks in the seclusion hut. The Lord of the Night rubs some on the legs of the chief, and the same is done to the new princess royal and his other titled siblings. The two young wives who are to share his seclusion hut have some of the mixture rubbed on the brass anklets they wear as royal wives.

80

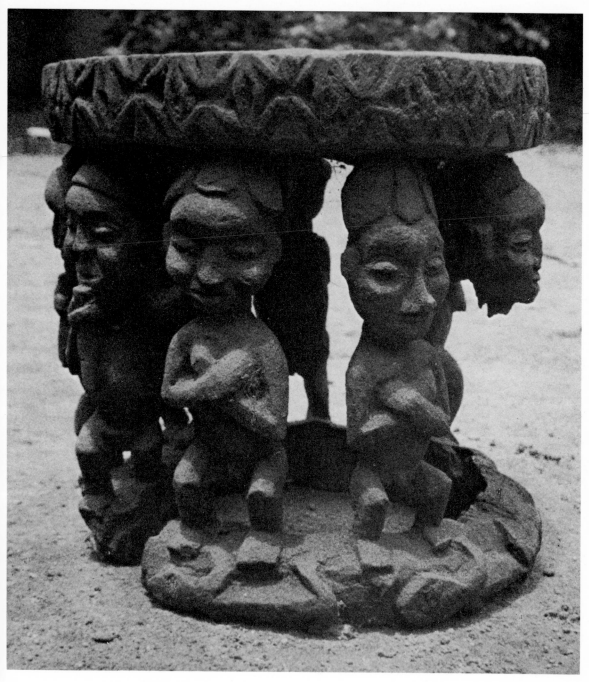

Plate 41 Royal stool, supported by retainers

The Lord of the Night, his great retainer, offers the young man palm wine medicated with more leaves and powders; it is put in the late chief's ceremonial drinking cup, made from the horn of a dwarf cow. The chief drinks. The Lord of the Night leads the young man to the carved stool, covered with a leopard skin. He is given a pungent seed to chew and seated on the stool. 'Now you are our chief. If your mother calls do not heed her. Do not befriend thieves or witches. Listen to the advice of the Night society; we will tell you if you do wrong. God has made you. He has given you your two hands: the left is for evil, sacrifice to the evil god with that; the right is for good, sacrifice to the good god with that.'

There is silence in the hut. From far away comes the sound of the cry. The Lord of the Night, kingmaker and head retainer, steps back from the youth and for the first time removes his cap. He motions to the other members to follow his example. The other royal children are beckoned closer. Half stooping the old retainer claps his hands together slowly – twice, three times – bringing his hands up to cover his mouth. In this way he makes formal obeisance to the new chief. The whole group clap their hands in the same way. The Lord of the Night leads the way into the skull house next door. There are eight clay pots facing downwards on the mud floor, covering the skulls of seven patrilineal ancestors and the skull of the late chief's mother (Col. pl. 8). Scattered on the floor are relics of the former chiefs: a clay pipe, a decayed eating bowl, a cap. Next to each skull is a carved ivory trumpet, blown by a royal retainer when formal sacrifices are made to the royal ancestors. The new portrait figure of the late chief has been placed in the position where his skull will be buried. The priest of the earth takes some of the anointing mixture and daubs it on the skull pots and the new statue. The Lord of the Night takes the medicated rattle and touches the skull pots with it. Finally, the people stretch out their hands, palms upwards in blessing, and a prayer is shouted by the Lord of the Night, calling on the country's ancestors to bless the new chief with long life, fertility and prosperity. The rite is over. With a great deal of chatter the kingmakers go back to the cry.

The new chief and his adjutants are taken by the old princess royal to specially prepared houses in the compound where they are to stay in semi seclusion for the next nine weeks. During this time they are rubbed with the medicine made that day, to which has been added more oil and red powdered camwood. The chief receives visitors, but answers their greetings only in monosyllables, peering out of the crack in his blue and white hood. During this period he and his consorts are visited by elders and members of the Nine who communicate to them many of the secrets of chiefship. The Lord of the Night society has mystical information reserved for the ears of the chief. He is believed, ritually,

to transfer to his master the late chief's attributes of shape-changing. These attributes are visualised by the Bangwa in the form of a twisted root or rope which is kept by the Lord of the Night society, as controller of the royal mysteries of witchcraft. The rope or root symbolises the royal powers without which a chief is unable to rule; but they are only transmitted when the Lord of the Night is convinced of the heir's worth and maturity.

At dusk the cry loses its momentum. The widows who have been tireless mourning their dead husband retire to their own huts and eat some food cooked by a relative. They are not allowed to prepare food themselves during the nine weeks of mourning. Relatives and friends sleep in the widows' houses; they themselves gather in the great meeting-house where they sleep on beds of dried plantain leaves and warm themselves before wood fires made on the clay floor. During the mourning period they will not leave the palace; their crops are tended and harvested by friends. They do not wash: they continue to rub themselves with oil which is removed in the final lustration and shaving rites.

THE CELEBRATIONS: THE GONG SOCIETY

The celebrations begin that night. The Gong society performs in the sacred copse on the small hill beyond the compound. It is appropriate that the gong music should be played on the night of the chief's installation. It is here in the sacred copse (called *lefem*, which is also the name of the society) where sacrifices are made to the country's ancestors. The gong music is itself a blessing, a harbinger of prosperity and fertility for the royal family and the country. In this sacred copse royal children are buried; but it is not a gruesome place, since the babies' spirits leave here to be reincarnated in the Bangwa 'heaven' (located in the earth, *ase*). Towards twilight the retainers of the palace bring out the gongs, drums and rattles associated with the Gong society. Retainers prowl the compound and dancing field warning all women and children to stay indoors from now on. 'Children', in this context, includes all men whose fathers are still alive. The women make a rush for the nearest house; some of them only feign terror, but they drag their children with them to avoid random blows from the retainers' staffs. Some of the young men in the market laugh and loiter awhile until they are driven with resounding whacks by the servants of the Gong society. When the compound is cleared the servants carry the gongs across the compound to the sacred copse, uttering weird shrieks and thundering warnings to the uninitiated of the terrible fate that awaits if they accidentally see the society's paraphernalia. The paraphernalia includes the gongs themselves, the *lefem* ring of clappers, carved trumpets and the *lefem* figures – effigies of the ancestors and other important royal status holders. (Fig. 18)

A small hut has been erected inside the copse. Until recently a permanent

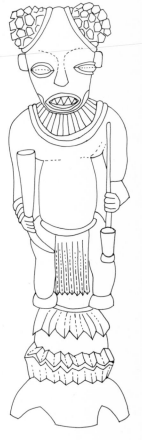

Figure 18
Ancestor figure

house was maintained; the meetings of the Gong society were held where the keeper of the sacred grove lived. Known as the 'gong beater' he was a slave who guarded the gongs and the statues. He lived in the wood, guarded the paraphernalia and performed menial duties around the palace, a strange, unkempt figure whose long greased hair was plaited and tied with cowries and small bells. He sacrificed at the sacred copse shrine, connected with the *lefem* figures, and acted as a messenger during wars and a peacemaker in local disputes. During his period of office (theoretically eight years) he was forbidden sexual contact with women but at the end of this time he was freed and given a wife. Today the duties of the keeper of the *lefem* grove have been taken over by their descendants, free men, whose main job is to share out the meat and wine during the performance.

Traditionally the Gong society meets annually for five or seven weeks – during the dry season – in order to propitiate the gods through music and sacri-fice and thus ensure the land's fertility. Each chiefdom has its special day on which the gongs are played. On that day no subject is allowed to work his farm, perform any physical activities, or even mourn the death of a child. During times of misfortune (drought, epidemic, a chief's illness) the chiefdom's diviners may advise a performance of the Gong society. Although the society meets in exaggerated secrecy and a good deal of importance is placed on the sacred paraphernalia, it is not a secret society in the usual sense of this phrase. Any adult male, whether a member or not, may enter the *lefem* copse and play the gongs: the sole qualification is that his father must be dead. Only members, however, may attend to discuss policy and punitive action. Membership is acquired by succession to the general bundle of statuses held by one's father; it is validated by the heir's entertaining the society as a whole at the late man's cry and formal payments. The number of goats and the amount of wine and tobacco to be offered depends on the rank held by the late member. But in this society where chiefship is fragmented, a wealthy man will not only aspire to membership of the chief's Gong society but will also want to 'buy' his own gongs and the right to play them in his own sacred copse. Minor nobles and subchiefs buy their sets of gongs, plus knowledge of the music from the chief; the society is in sections, only one part of its secret knowledge being imparted each time. This is true for all the societies mentioned in this chapter. 'Owner-ship' of dances, songs and the rights to play instruments and wear masks are transferred section by section to ambitious title-holders.

The gongs are of all sizes. Only the paramount chief is allowed the largest, the great *fombi*, a huge gong almost five feet high. The smallest is a pair only six inches high. The gongs are made by the local Fontem blacksmiths, retainers of the palace, and their work is theoretically the property of the chief. The gongs

Colour plate 11
Compound during a cry

Colour plate 12
Drummers at a cry: the carver, Atem, tries out a new slit-gong

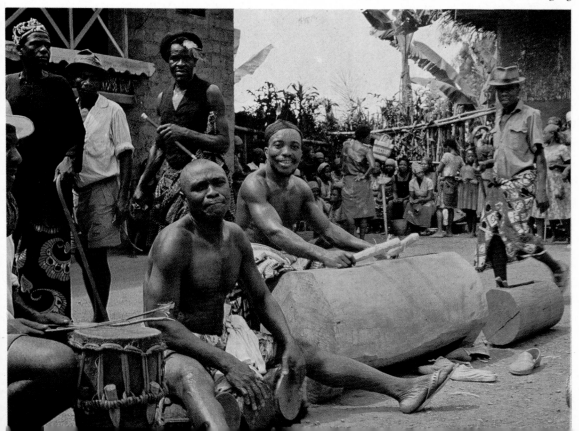

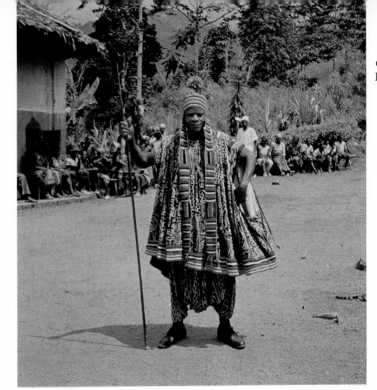

Colour plate 13
Bangwa noble in ceremonial dress

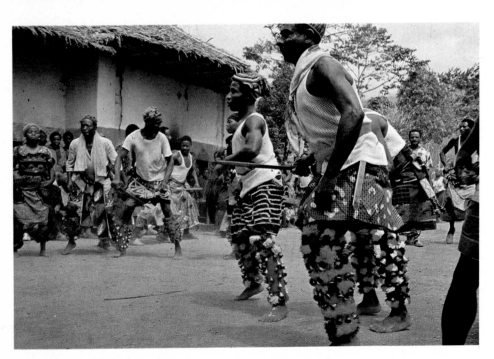

Colour plate 14
Heralds, wearing bell leggings, announce the arrival of a mask

are made by the Fontem smiths from scrap-iron since they do not smelt, pre-colonial hoes apparently providing the best tone. They are exported all over the Bamenda and Bamileke grassfields. The head of the blacksmiths, Ngangala, is an important royal retainer; his prestige in the Gong society is recognised and he has a special rank inside it alongside free nobles and ranking members of the Nine. The gongs (Plate 42) are technically bells: two-sided hollow bells which are hit with a soft stick. One side is a semi-tone higher than the other and each bell varies in pitch according to size. When they are played together the effect is beautiful, the tinkling of the smaller gongs merging with the mellow tones of those of middle range. The gongs are accompanied by drumming and the fierce jangle of a ring of clappers; this latter instrument (called *nduh* when associated with the gong music) is in fact similar in form, if not in power to the rattle associated with the Night society – the 'loins of Night' (Plate 39).

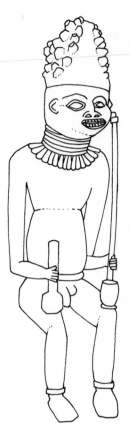

A performace of the Gong society is one of the rare occasions on which the ancestor statues (Fig. 19) are brought out from their dark hiding-places in a chief's skull-house or a wife's loft. They are placed inside the copse under the awning erected to shelter the chiefs when they attend the next day. In the past they were left in the care of the Gong society's retainer but there are no longer perma-nent retainers or houses associated with the society. One figure is always placed at the entrance to the copse to warn off children and women (Col. pl. 10). These statues, with the gongs, are the symbols of chiefship *par excellence*. Unlike the masks of the Night society they are symbols of the good aspects of chiefship. They are associated with a royal ancestor cult, as it affects the royal family; but they also play their part in a wider cult involving the ancestors of the land and centred on the sacred *lefem* copse. The figures are not only of royal ancestors but may portray retainers, royal wives or the chief's mother. They play a part in annual ceremonies performed at chiefdom godheads – the grander natural phenomena like waterfalls, giant *boma* trees, mountain peaks. During these rites the priest of the earth (*tanyi*) sacrifices a white ram on behalf of former chiefs, princesses royal, titled wives, great retainers and councillors.

Figure 19
Ancestor figure

Before entering the *lefem* copse all men take off their shoes. Those wearing trousers or forest-style sarongs remove these as well, covering their thighs with a loincloth drawn up between the legs in traditional style. As the performance is about to begin, an assorted pile of objects collects around the splendid statue: plastic shoes, ragged trousers and umbrellas. The society performs through the night, the music echoing eerily around the Bangwa countryside. The great retainer, who ranks high both in the Gong society and in the Night society, takes up the largest gong, from whose mystical powers he alone is protected. It booms out above the gentler tones of the other gongs. Another man picks

up the rattle, shaking it up and down to add a strident sound to the gong melody. An expert player is always at hand, who checks the rhythm of individual players and sends away youngsters who cannot master the intricate cross-rhythms. The only women present are the princess royal and women who hold equivalent status in neighbouring chiefdoms; they join in the dancing but do not play the gongs. At the end of the sequence the gongs are carefully placed on the ground; the rattle is put down with exaggerated care.

Not until dawn do the performers on the gongs retire to local compounds. There they sleep a few hours before the main business of the cry begins later that morning.

Plate 42
Gongs of the *lefem*
society

86

In the palace, preparations for the festivities start early. Pigs scream as their throats are cut. Pestles thud as fufu is pounded from boiled yams and cocoyams. The wives' houses overflow with willing helpers who receive gifts brought by friends and relatives. Elaborate steamed puddings are made from ground beans, corn, groundnuts and melon seeds. Meat is cooked outside in huge iron pots. Groups of men arrive bearing demijohns of wine.

By late morning the field is full again. Elders and chiefs leave the meeting-house and take their seats according to rank. Chiefs with their titled wives and sisters sit on one side, subchiefs on another, lower ranking nobles on another; and commoners, women and children form a mass of spectators at the far end of the dancing field. Servants stalk through the crowd keeping order. Tidbits and drinks are placed in front of the important visitors: kola nuts, beer and French wine, huge calabashes of palm wine and biscuits. The drinking, laughing, shouting and quarrelling begins. These dances and performances may last for four or five days for the funeral of a chief; for ease of description we have condensed them into one. The dance groups and masqueraders have their own houses: some of them take over wives' huts, others have special pavilions built for them behind the dancing field. Here they spend the time practising their songs and dances, and enjoying the food and drink presented to them by their hosts.

The new chief and his titled brothers and sisters are to visit the *lefem* for a performance of the Gong society before the public dances begin. The retainers helped by the old princess royal dress the chief. The heirs are all rubbed with the medicine made the previous day and the camwood, the reddish bark-powder, gives their bodies a fine copper glow. They put on their hoods out of which they peer inquisitively as they make their way secretly, avoiding the crowds, to the sacred copse, where the members of the Gong society are waiting. Today the chief is purely an observer; but his presence there and his gift of meat, wine and tobacco, confirms his succession to his father's status as head of the society. He, as chief, does not remove his shoes on entering. The members greet him with the traditional yodelling cry as he sits under the awning beside the *lefem* statues. The gongs are laid out in the clearing and at a sign from an elder the players take up their instruments and the melody of twenty-five gongs filters through the undergrowth and interlaced branches towards the compound, mingling with the noise of the crying widows who have just shuffled on to the field. The drums and rattle join in.

After a time food and wine are brought in and placed in front of the chief, who bids the retainer divide it according to the rank of the members. Bowls full of roast goat meat and huge calabashes of wine are placed on the ground

in front of groups of men. Eating in the sacred copse is a formal occasion. Members eat out of fine receptacles; specially designed pads are placed on the ground to take the wooden bowls. Wine is drunk out of carved horns poured from beaded calabashes. Before anyone tastes their food a special portion is given to the gods. A retainer blows a loud blast on a trumpet (Plate 11) which echoes above the trees and is answered by a shout from the crowd outside. An elder of the society leads the chief to the shrine; a stone cavity is uncovered in the centre of the clearing. The trumpet has summoned the gods to eat. The chief utters a few words of blessing, prompted by the elders: he calls on his ancestors and the gods of Bangwa to bless the country and make him and his people fruitful. Another man takes up the prayer as the chief pours wine and places food in the shrine. Wine is also splashed on the ancestors figures under the awning. Then with hands outstretched, palms upwards, all present blow a benediction towards the abode of the gods in the earth. The stone lid is slid back into place and the group settles down to eat and drink in silence.

The chief, supported by the old princess royal and his retainers, now leaves the copse. The gong music will continue throughout the day, as a counterpoint to the crying and singing from the open field. The royal party approaches the field where it is met by a lone masked member of the Night society who conducts it to an alcove at one side of the field. Ululations come from the women and men clap their hands in formal greeting. The chief remains aloof. He sits with his two brothers and sisters on the dais, peeping through his cloth at the crowd, and making no sign, as he receives the gifts and greetings of his subjects.

The performances are about to begin. The widows will keep up continuous mourning, supported by kinsfolk of the late chief; but the field will be taken over by cheerful, colourful dancers and masqueraders. The organisation of the separate spectacles is left to the palace retainers and older 'king-boys' (royals); nowadays programmes are written out by schoolboys and handed round to important guests. The palace retainers spend most of their time beating back the crowd and keeping control over the dozens of dancing groups each of which tries to exceed its allotted time. The performance of an individual society, however, is strictly controlled by its own officers. The presentation of the dance and masks is a professional affair. The dancers dress in a shelter constructed of palm fronds, high up on the forested hill above the dancing field. Maskers and dancers are announced by heralds who appear on the field, leaping about in front of the spectators, pushing back unruly children and, in dumb show, announcing the arrival of the masks (Col. pl. 14). These may be followed by other heralds intent on building up the excitement. The drums or xylophones are manned by special teams expert at the type of music associated with each juju. The masks themselves are eagerly awaited by the crowd who

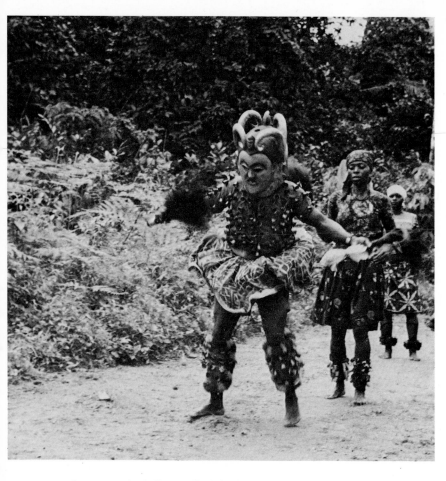

Plate 43
Masked dancer
approaching the field

gaze upward towards the hill. Small children are sent to climb the trees surround-
ing the changing-huts: they wave the branches furiously and hoot as the first
maskers come out of the bush. These dance gingerly down the steep path: the
masks are heavy and the costumes elaborate, and a fall would be a blow to the
prestige of the society. Minor masks, accompanied by people in costume, appear
first. A circle of dancers is formed (Col. pl. 11) and in most cases the onlookers
are allowed to join. The masker remains outside this circle: as each one appears,
accompanied by its own attendant, the masker dances before the chiefs and
nobles who reward them with small coins. The dance is simple, if energetic.
On the whole there is little miming or narrative dancing. The high spot is the
appearance of the most important or newest mask. There is a flash of colour in
the bush, the masker appears with his retinue (Plate 43); he leaps down the
path and appears on the field for a moment before disappearing back into the

leaves. When the mask appears its owner leaps up from the ranks of spectators (if, as often happens, he is not performing himself) and shouts at his wives and people to ululate in appreciation of the mask and the skilful dancer.

During these performances the identity of the masker is unknown. But this is unimportant: the mask is the thing, not the masker. The mask comes from the world of the forest as if by magic, appearing for a second in the world of the cry. Young men, strong dancers, are asked to wear masks and receive as a reward large portions of the food and wine allotted the society by the hosts. The personality of the dancer is entirely subordinate to that of the mask. The dancer's face is obscured, covered entirely either by the mask (if it is of the helmet or face type), or by extensions made of cloth or raffia tied to holes in the base of the mask.

After these brief glimpses of the masks, the music continues and men and women join in a circular dance around the musicians.

THE DANCE OF THE MOTHERS OF TWINS

The order of the different performances is not strictly laid down. In some chiefdoms the headhunting society, Challenge, opens this part of the cry. In others a dance is performed by all the women of the chiefdom who have given birth to twins. Parents of twins (*anyi* for a woman, *tanyi* for a man (Fig. 20)) are given a special role in all matters concerning fertility and the earth spirits. A father of twins (*tanyi*) may become a priest of the earth and performs innumerable rites from the 'fattening' of adolescent girls to country-wide fertility rites. *Tanyi* has had an important role during the crowning of the chief. Mothers of twins perform at the cry: their dancing and singing of the song of the earth benefit the new chief, particularly in his role as head of a large and prolific compound of wives. The new chief, once crowned, is not called chief but *tanyi sö* ('new father of twins'): his title of chief is accorded him only after he has fathered a son and a daughter. The twin-mothers dance slowly into the circle of widows. They wear the badges of their status, beaded torques, or circlets of cowries, and carry long branches of the *nkeng* bush (*dracæna*), waving them from side to side in an act of benediction. High-ranking *anyi* (older ones, the mothers of triplets or two sets of twins) lead the dancers with rattles. Some of the older women wear their hair in long plaits tied with cowries. The crowd joins in the singing and dancing. A *tanyi* leads the singing from the centre.

Bangwa sculpture, in the past, took inspiration from these twin parents; statues were carved both of *anyi* and *tanyi* with one or two children (see p. 124) (Plate 44; Figs. 15, 20, 21 for further details).

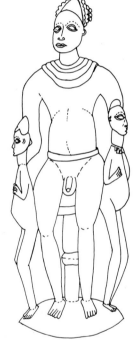

Figure 20
Father of twins

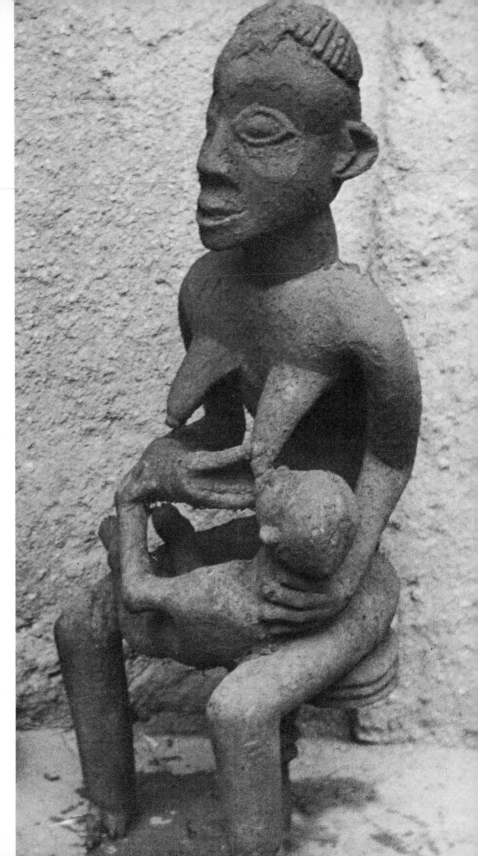

Plate 44
Statue of mother of
twins

Ngkpwe is a warriors' society. It is called here 'Challenge', a loose translation of the Bangwa word. The slaying of an enemy and the presentation of his skull to the chief gave a warrior, and today his patrilineal successor, the right to perform in the Challenge dance. In the past members were brought into the service of the chief, acting as police in association with the Night society. Challenge seems to date from the time when the Bangwa and their Mbo neighbours fought incessant guerilla wars for human booty and rights over rich forest palm groves. The Bangwa claim that the Mbo kidnapped their men and women to satisfy their lust for human flesh. The Mbo, who admit to cannibalism in the past, declare that the Bangwa raided for slaves and also acquired a taste for human flesh. Today the past activities of this headhunting group are only a dim memory. The group meets at the funerals of its members; it has no regular social or economic function in society at large. The Bangwa say that it is indigenous – thus placing it on a par with the Night and Gong societies. Nevertheless the style of the masks reveals its origins as Cross River-Ekoi. The other two Bangwa military associations (*manjong* and *alaling*) are associated with the formal Bamileke cultures; unlike these organised military brotherhoods, Challenge involves individuals rewarded for individual prowess.

The late chief's Challenge society takes the field first. Beforehand the old princess royal organises the maskers and dancers in the makeshift hut above the dancing field. There are heralds, with leaves and feathers in their hair; the maskers with their long sacking robes and head masks; and the run-of-the-mill dancers. Everyone busily prepares his costume, offering help to others if needed. Then they sit and wait in a circle around a demijohn of bubbling raffia palm wine which has been presented, to the group, by the cry's organisers. The princess royal shares out the wine – into blue kettles, cow horns, enamel basins. When it is almost finished a retainer approaches, informing the group that the twin-mothers have moved off the field. The heralds leave the hut with a flourish, sprinting down the high steps to the field, brandishing branches and guns. They form a line in front of the new chief and his retinue; they dance on tiptoe, their feet wide apart, leaning forward slightly, their whole bodies vibrating as they frenziedly beat their feet on the ground as though on the taut membrane of a drum. The chief inclines his head towards them and they leap back, firing their guns into the air. The crowd roars. Then at the top of the steps appears a high, robed figure, swathed from top to toe in sheets of woven plaintain fibre or sacking (Col. pl. 16). Two feet are added to his height by the mask on top of his head which is entirely concealed from view by cloth, which forms a kind of veil over his face (Plate 16). A large circular food-basket is tied to his shoulders, under the robe, giving him a monstrous hump-

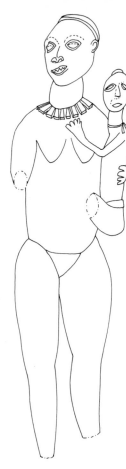

Figure 21
Mother and child

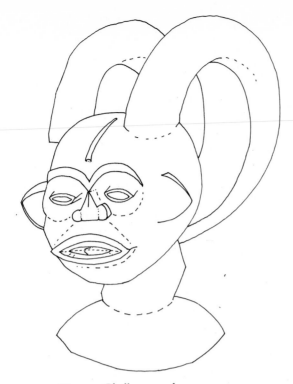

Figure 22 Challenge mask

backed appearance. He is escorted by men in loincloths, all carrying in one hand a cutlass and, in the other, a bundle tied up with leaves. This bundle contains the skull of a slain enemy or its imitation – an animal's skull or a round stone. Slowly the group of Challenge dancers moves round the field, to the cross-rhythms of three drums which are played in the middle. The widows still maintain their slow shuffle, but their singing has stopped. The masker is joined by a second and a third. They dance back and forth, holding out their billowing cloths like mannequins. Then the princess royal dances down the steps preceding another figure who whirls round the field holding a tinkling brass bell in each hand. The figures present themselves to each side of the arena; first the chiefs, then the subchiefs, nobles, commoners and women and children. Back in the centre their hands fumble at the cloth caught up on top of the mask. It falls down and reveals, perhaps only for a minute, the Challenge masks themselves.

The masks of the Challenge society (Plates 10, 16, 45; Figs 22–24) are in fact not masks at all in the sense of covering the face, but wooden heads,

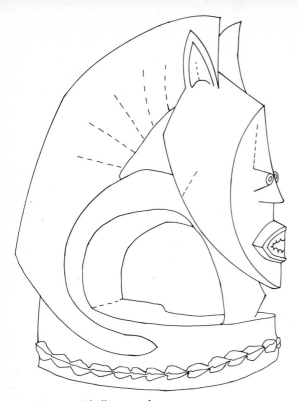

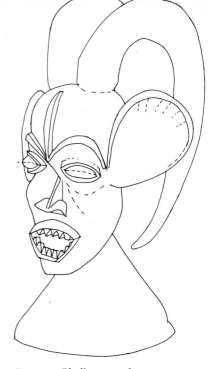

Figure 23 Challenge mask *Figure 24* Challenge mask

tied on to a platform and then fastened on to the head of the wearer. One
characteristic is their comparatively small size. They are usually surmounted
by horns, or an approximation of horns, that often resemble muddied hair-
styles. The mask represents physical prowess – whether of the conqueror or of
the conquered is not certain. The Bangwa give varying explanations of the
masks: they are the heads of defeated enemies; they are the busts of the valiant
warrior who captured the head. The classic face shows a human head with
horns sweeping up from the forehead and then to the back of the head (Fig.
22). Horns are a common power symbol and also appear on the Royal
and Night masks (Plate 15, Fig. 41). The addition of horns or hair gives
height to the wearer since the mask is worn under the voluminous head-dress
of the costume. Other features of Challenge masks include raised eyes and
finely chiselled noses. Some have separately inserted bamboo or wooden teeth
(see Plate 16); others have real hair; some are round, others elongated. No
examples are known where metal is used for eye decoration or teeth. The variety
is overwhelming and little generalisation is possible; there are a multitude of
extant examples, most of poor workmanship (for an example see Plate 16).
Sometimes small articulated figures are worn (Plate 46). Their relation to many
examples of published Ekoi work[1] is clear. It is important to note that

94

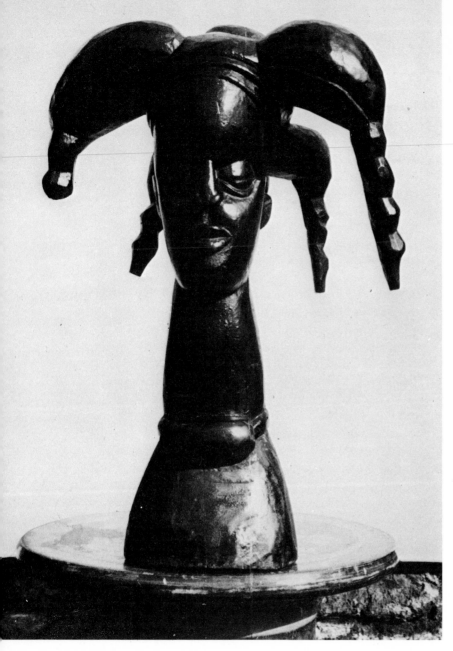

Plate 45

This most elegant of Challenge masks retains its typical shape: a small head on an elongated neck which spreads out, eliminating the necessity of a basketwork support for attaching the mask to the head. It is painted; the face is reddish and the 'horns' black. Some Bangwa say the horns are not horns but hair: the artist converted the idea of horns into an elaborate hairstyle. Around the chin there is a painted line, suggesting the line of a beard. The eyes are carved with lowered upper lid; the nose is finely delineated; and the lips protrude realistically. The face itself is finely finished, the base of the neck showing the rougher marks of the carver's knife.

the similarity of styles does not in this case reflect a similarity of function; the Ekoi cult groups concerned do not appear to have any connection with head-hunting (Figs 22 and 24 are typical Challenge masks). In Fig. 22 the mask is almost completely circular with the head set on a curiously shaped neck which connects with a circular base, and a vertical tribal mark from the centre of the forehead to the hair-line. The horns are carved as if detached from the head and join the neck at the back. The features of the face are enclosed in a circle, forming a heart-shape; the nose is flat and huge grimacing lips open around the protruding tongue. The features are incised on to the ball-shaped head, so that the horns, rather than the face, impress the spectator. Modern examples of this type of Challenge mask are frequently painted in gaudy reds, blues and yellows. Similar masks have been found far south of Bangwa in the Kumba region, although often without horns. One (Fig. 23) called 'Bamileke', is illustrated in Wingert.[2] Another accredited to the Bangwa (Fig. 24) is illustrated in Krieger.[3]

After the presentation of the Challenge masks the drumming continues and the spectators join in a general dance. They dance until the drummers tire or the palace retainer in charge of the performances announces the arrival of the next group. If several Challenge societies are to dance, they follow in quick succession after the society of the senior chief. There is often a long interval between the performances. These breaks are used for meeting friends and strolling with them round the compound. A group of nobles, from a distant chiefdom, are told in a whisper that their food has been prepared in the meeting-house. Somebody turns up a transistor radio which blares forth in distorted French. Disputes about protocol – the order of appearance of the societies – may interrupt proceedings. Quarrels spring up between musicians and dancers. Sometimes a group refuses to perform because their entertainment (in food, drink and tobacco) has been mean. At one cry-die the host per-functorily stopped all the celebrations until each of the late man's sons-in-law had paid their death levies to his heir. To an onlooker there is considerable chaos in-between dances, although this is more than made up for by the enthusiasm and efficiency of the individual masquerades. Often, despite the strenuous activities of the ritual expert in charge of the weather, performances are washed out by a tempest and postponed until the next day.

'ALALING' AND 'MANJONG'

There are two other warrior societies in Bangwa. *Alaling*, the spy society, acted as an advance scouting party during campaigns against the Mbo and Bamileke. Its members are feared and hated by the Bangwa today and nicknamed the Robber Band. The spy society dances on to the field with crouching, sweeping

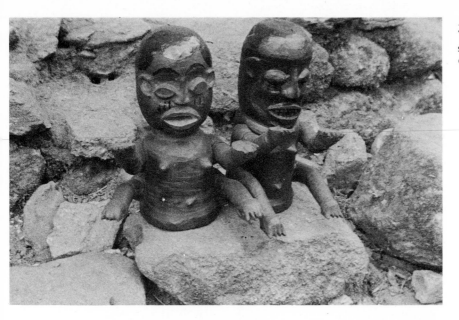

Plate 46
Two articulated dolls,
skin-covered, worn in the
Challenge dance

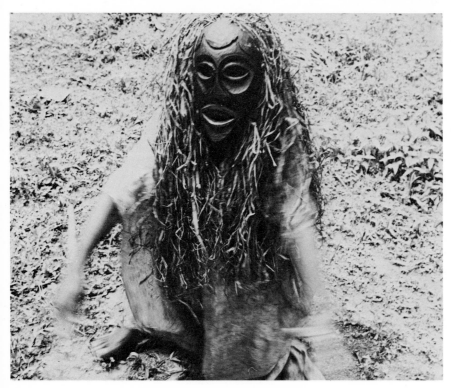

Plate 47
A masker of the Spy
society (*Alaling* society)

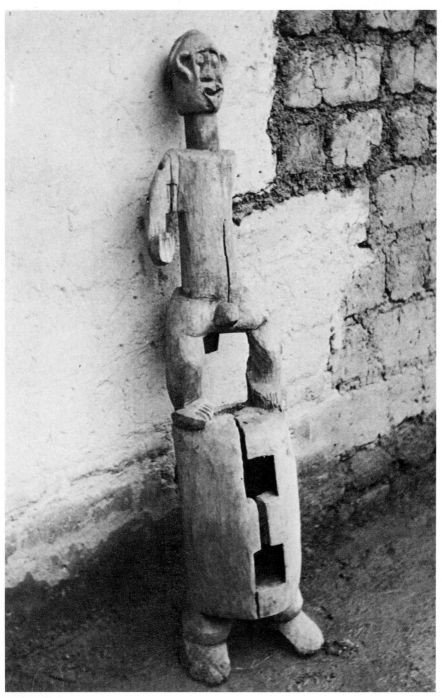

Plate 48
Drum with human figure,
played during the dance
of the *Alaling* society

gestures (Plate 47). The dancers wear face masks, wreathed in flowing raffia and as they dance round the field they hoot: 'No, we won't steal today.' The first figure appears from the crowds, dances out into the open and is joined by two or three others. Together they make a tour of the field, always crouched low, squirming in and out of the screaming crowd, stealing food and drink and anything they can get their hands on. Unscrupulous chiefs have been known to use *alaling* for depredations on the food stocks and other property of their subjects. Apparently the costumes were used recently by Bamileke terrorists in their night attacks on traders returning with goods and cash from local markets. The society has been banned by the authorities in East Cameroon. The masks show a typical heart-shaped style: two lines curving out from two arched brows and extending down to the mouth. Some fine examples of *alaling* drums have been recorded, many of them carved with human figures. They are carried by one of the dancers (as they were carried at war?) and beaten by the drummer as they follow the masqueraders through the field (Plate 48).

Challenge glorifies individual warriors and *alaling* is a close-knit palace society. *Manjong* (a Bamenda term, the correct Bangwa name being *afuka*) is a nation-wide association of soldiers open to all men. It is found in all Bangwa chiefdoms and is based on citizenship, not on age grades as among the Bamileke. In times of war the *manjong* groups of the subchiefdoms and villages come under the head of a national *manjong* leader who is usually a titled palace retainer. Nowadays the functions of *manjong* have changed: the young men, under their immediate leaders, meet monthly to organise dances and feasts associated with savings clubs. When a member dies the group prepares the body and bury it. The chief nowadays uses the members of the *manjong* club to carry out community work – road-building or hauling a slit-gong from the forest to its position in the market.

Manjong performances at a cry are highly organised, even militaristic. There are captains, lieutenants, messengers – ranks all shown by the insignia worked into their costumes. The *tandia manjong* ('the owner of the house of Manjong') wears the most elaborate costume and precedes the dancers, carrying a bundle of ceremonial spears. The dancing consists primarily of a riotous mock battle, spears held high and brandished at each other and the spectators. Dancers carry branches of the *ka* tree, formerly used for camouflage. They make an extraordinary attack on the dead man's plantains, cutting them down with cutlasses, and on one of his huts, often completely destroying the framework of a door. This action is explained as 'their right to their share of the dead man's property'. In fact presentations of meat and wine successfully put an end to their maraudings. In the past the *manjong* costume consisted of beaded masks, with tiny cymbals tied to the ankles. The beaded masks have now rotted away

and been replaced by patchwork and embroidered masks, which in many cases a member makes himself (Plate 49). On their ankles the dancers wear the same rattles of large seeds, or bottle-tops, that the women wear for their dances.

THE ELEPHANT SOCIETY

At a sign from the retainer in charge, the drumming stops and the *manjong* dancers, after a moment of suspended animation, are hustled off the field. The spectators are roughly pushed back off the field and the word goes round that the *aka* society is about to appear. *Aka*, or the society of the Elephants, no longer flourishes in Bangwa generally. It is a society which originated in the east, among the Bamileke chiefdoms; like most grassland jujus its popularity has been superseded by exotic societies and dances from the forest. Membership of the Elephant society is limited by rank and wealth, but not by age. There are three grades and members move up according to payments. Access to the highest grade used to be gained by the payment of a slave to the chief, owner of the society. Some chiefs quietly but proudly point out members of their families descended from one such 'payment'. The costumes are called 'things of money' since they are made entirely of beads stitched on to plantain fibre and stretched over raffia frames (Plate 50). These beads, *kpeng*, formerly trade beads, were used for buying slaves and European goods in the past. The Elephant society, like the Gong society, had its special day in the eight-day week when members met and feasted. According to members, on that day people were forbidden to stir from their compounds. Women did not go to the farms, drumming was forbidden, no firewood was chopped; even cocks were covered with baskets to prevent their crowing, which would have incurred for their owners a stiff fine from the head of the society, another palace retainer.

The Elephant society appears to the accompaniment of a single drum and a gong. There is relative silence among the spectators, as the maskers lope in slow motion round the field, waving poles with blue and white beaded tips and edged with horsehair. Then the masked figures appear at the top of the slope leading down to the palace. They carry spears and horsetails which they brandish, in slow waving movements, and they whistle mysteriously and tunelessly as they gyrate in front of the crowd. Their feet are bare, and their legs appear bright red with camwood below the indigo robes made of 'royal' cloth. Their beaded masks flap heavily round them. Each mask is basically the representation of an elephant, though some have features added from fantasy: birds attached to the head-dresses, horns appearing from the back. The mask fits tightly over the head and hangs down behind and in front to represent an elephant's trunk (Plate 50). Two huge stiffened ears are hinged on each side

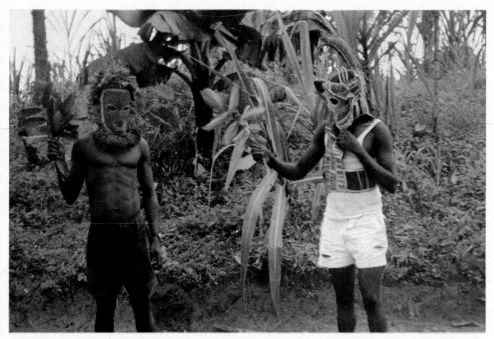

Colour plate 15 Manjong maskers

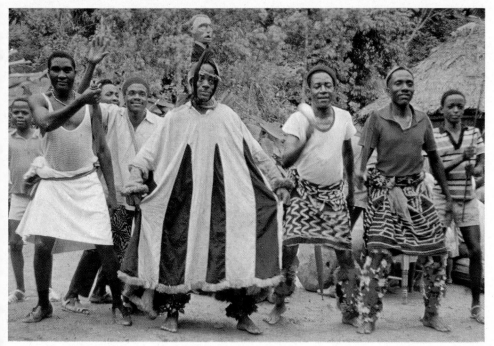

Colour plate 16 Dancers wearing bell leggings present a Challenge mask

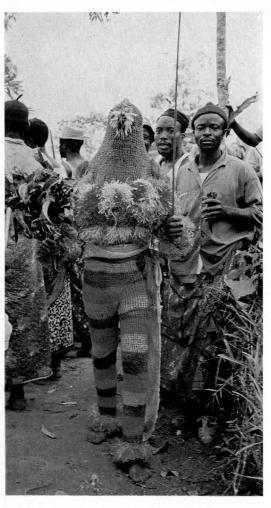

Colour plate 17 Leopard society fibre costume

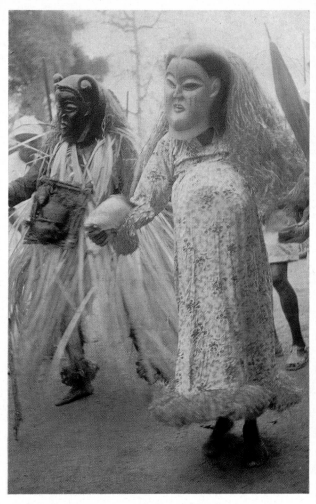

Colour plate 18 'Husband and wife' of the Leopard society

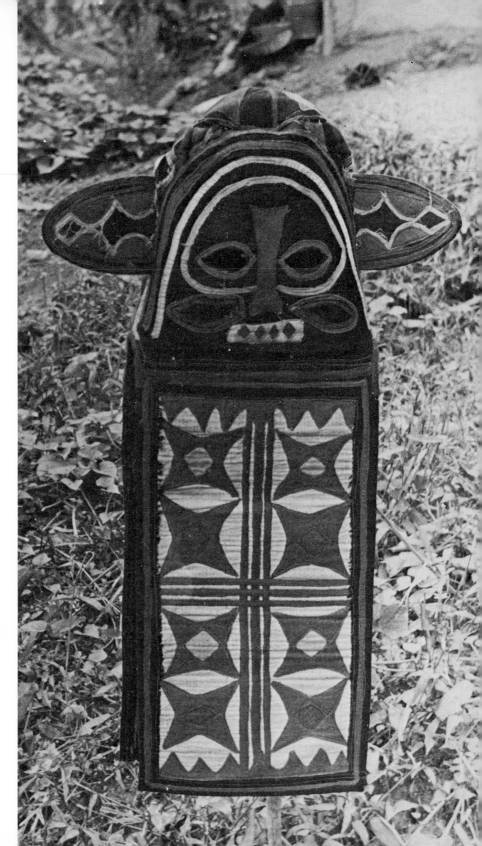

Plate 49
Manjong mask. In many
ways it appears to resemble
the beaded masks of the
Elephant society (Col.
pl. 7) with its flapping
ears and hanging 'trunk'.
It also shows a close
resemblance to the carved
masks of the Night
society and the faces of
the ancestor figures.
The ears, eyes and teeth
are portrayed in patchwork
in the same style as the
features carved in wood.
Even the puffed cheeks
around the eyes correspond
to the vast hollowed-out
spheres in which the
eyes are carved in the
mask and fetish

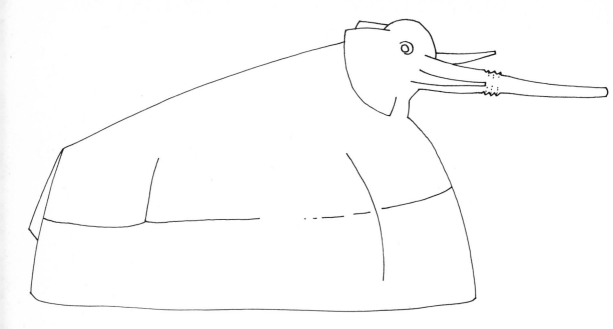

Figure 25
Elephant machine

of the head and flap strangely round them. The older masks are made of the older khaki, white and dull-red beads. Newer masks, of the kind that can still be bought in nearby Bamileke chiefdoms, are travesties of the originals. They are made of garish, larger beads, which barely cover the hessian or sheeting on to which they are stitched. The masks themselves have shrunk to ridiculous proportions, with minute ears and a shrivelled trunk.

The Elephant maskers are joined by energetic chiefs and their princesses. One of the older 'king-boys' runs to the centre of the field and takes over the drum. The maskers pass the elaborate tent in which sit the men of highest rank; one of them hurls his horsetail at an important chief who catches it with aplomb and throws it back. The crowd cheers. Then the music stops and the crowd's attention is drawn to a commotion inside a group of trees to the left of the field. Small boys, stationed in strategic positions, furiously shake the bushes. A huge object, covered with brightly painted hessian, lunges from the copse. It is the Elephant himself (Fig. 25), a vast model animal made of material stretched on to a palm rib framework. It has a long swinging trunk which sways heavily towards the crowd. It is manœuvred by a group of young men whose legs can be seen moving under the machine. The Bangwa gasp: the creature has been brought by a neighbouring chief to honour his dead friend and it is the first time they have seen it. It lurches and totters once across the

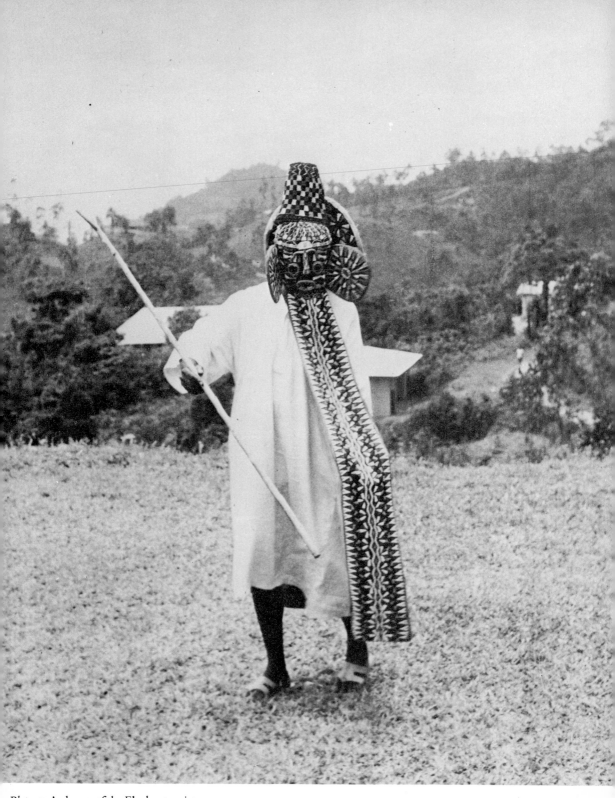

Plate 50 A dancer of the Elephant society

field and out again into the opposite bushes, accompanied by a roar of appreciation from the crowd.

After the success of the Elephant society there is a long interval. The crowd disperses temporarily. Elders approach the royal alcove and make their obeisance to the chiefs – the handclapping, hands to mouth, and bow due to men of the highest rank: women approach, stooping low and stamping their right foot on the ground in a dramatic gesture of subservience. Favourites are rewarded with kola nuts or a glass of wine. The new rulers remain demurely seated, their feet and faces only visible, their skin glowing from the red camwood and oil. Other royals, their titled uncles and aunts, and subchiefs, then rise and leave the field to prepare for their own dance, *alungat-shaba*, called here the Royal. However, it is still some time before the heralds of the dance run into the field; the dressing of the dancers, including the chiefs themselves with their princes and princesses, is a lengthy and elaborate business.

THE ROYAL SOCIETY

The Royal society's one purpose is to present the chiefs and their relatives ('king-boys') in their greatest glory; it appears only at the funeral of a member of the chief's family. It is not a society to which members may join by paying fees: it is primarily a dance, the accoutrements of which are the prerogatives of royals. The costumes, masks, horsetails, leggings and so on are elaborate and very costly. Dancers wear nineteenth-century waistcoats and jackets with fringed epaulettes and red flannel gaiters (Col. pl. 14); their headgear consists of soldier's felt hats traded from the Germans who occupied their country in the early years of the century. Wealthy chiefs are the proud possessors of brass helmets, highly polished and decorated with colourful plumes. One chief sports an artificial beard made from the fine-haired beard of a ram (Plate 51). The costume of the women resembles that of the men; they wear similar hats and coats borrowed from their male relatives. The red felt leggings of the dancers and the royals, and their waistcoats, are covered with a mass of tiny brass bells which makes each performer tinkle with a myriad sounds. Hundreds are needed for one costume. These bells are about an inch long and were presumably brought by traders during the early years of the slave trade. They are no longer procurable, though local blacksmiths have tried to turn their hand to them, without success.

The masks of the Royal society are as colourful as the costumes (Plate 17). Their style is unique among Bangwa masks. Their heart-shaped faces and gentle surface gradings differentiate them from the Night society masks. They are still manufactured in fairly large numbers by local carvers. Unlike the masks of the Challenge society, which have parallels in the sculpture of

Plate 51
Chief Fontem dancing the Royal masquerade

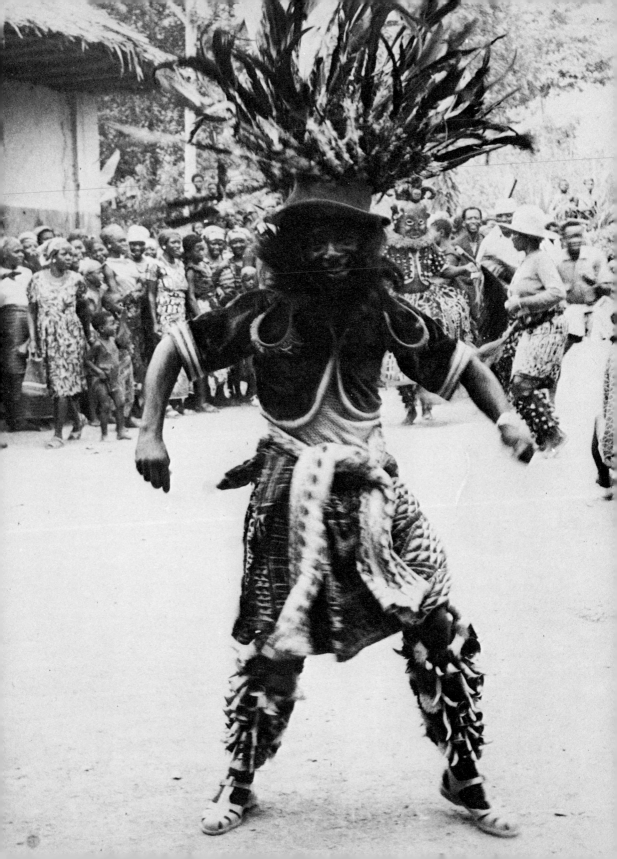

the Ekoi peoples, these appear to be restricted to Bangwa. However, the protruding eyes, the addition of horns and the skin-covering, show that they are related to Cross River-type head masks although huge Janus masks of this type, typical of the Royal society, have not been exhibited or published from the Cross River area. In early district officers' reports on the Mbo, Bangwa's southern neighbours, the presence of a society called *alungatshaba* (the Bangwa name for the Royal society) is noted and further researches may unearth Royal-type masks in this forest area. During performances of the society in Bangwa, cloths of the forest, rather than grassland, style are worn.

The Bangwa make it clear that these masks are intended to be as spectacular as possible. And within the basic form (helmet-shaped, low relief) variation is striking. They may be one-, two- or four-faced. Only the front face has 'seeing' eyes. They are decorated on top with plumes, pieces of mirror and horsehair. Some of them are surmounted by small carved heads or figures (the chief's defeated enemies or his slaves) (Col. pl. 3). In the older examples the top ornaments are carved in one piece with the mask; in the new ones they are usually pegged in later. Horns are added: again they symbolise power, usually that of the ferocious bush-cow. They may be carved with the mask, but more commonly they are added separately, even in the old examples. Stout vines are soaked till malleable and wound into a spiral shape. For the thicker variety of horn, flat vines are wound round a peg of wood before being skin-covered to give the realistic striated effect of an antelope's horn.

Most examples of the Royal masks are skin-covered and coloured with camwood or the red kola nut. Hair-line and beard may be suggested by a darker pigment. Today many are in fantastic polychrome: reds, greens and oranges, with multicoloured plumes of feathers and hair stuck in the top of the mask. Hair and beard are sometimes suggested by raffia-plaiting in a subtle and effective way. These royal masks are changing in style today. The restrained expression of the face in older examples is giving way to more exaggerated features: open, curling eyes and grimacing mouths (Col. pl. 14). This reflects the artist's own inspiration rather than any changes in the role of the contemporary Royal society.

The dance of the Royals is possibly the most elaborate of the cry. The drumming begins and a group of dancers pounds down the steep path. The dance is energetic and horsetails are waved in a slow counter-rhythm. The rank of a royal dancer is shown by the number of horsetail-whisks he carries: two for the family of a paramount chief, one for a subchief's. A tiny girl, a chief's favourite daughter, dances in, wearing her bright indigo cloth over a vast crinoline hoop made of raffia and on her head a bright, white sun-helmet. People rush on to the field and press money into her hands and into her mouth.

The dancers leap across the field and disappear into the palace courtyard behind the stands, hurried along unceremoniously by one of the heralds. The first masks appear: helmet masks, not worn by the king-boys but carried by anonymous, trained dancers. Most of the crowd know the masks of old, but a newly carved one or an original mask from a distant chiefdom is greeted with shouts of appreciation. The maskers turn and turn about, showing off the two-sided or four-sided masks to advantage. The herald ushers the group of maskers from the field as the drums begin to beat in a more energetic and inspired manner. A paramount chief appears on the top of the steps, flanked by two of his titled daughters (the princess royal and *angkweta*). His costume is magnificent. Fastened diagonally across his chest, over the red felt waistcoat, is an elaborately beaded snake, pink, purple and green. The chief's chest is studded with tinkling bells. In his hands he carries two carved ivory horsetails. On his head he wears a splendid beaded cap, with the sprouting snow-white hair of a ram's beard. His entrance is greeted by shrill ululations from his wives, while his followers call out his praise-names. He is joined by other chiefs who dance in pairs, opposite each other, slapping the palms of their hands against their partners in a gesture of equality.

Throughout this tumultuous performance the new rulers still sit calmly watching, attended by their retainers and flanked by one solitary Night society masker. The performance of their fellow chiefs is watched with interest. The old princess royal whispers into the ear of the new chief. Obeying her instructions he sends a servant on to the dancing field with a thousand-franc note which is stuck to the glistening brow of the gorgeously bedecked chief who performed so well. He is the *tangkap* of the young man, the marriage lord of his mother and an important relative. The chief dances in front of the veiled chief for a few moments and then fires his Dane-gun into the air before disappearing into the palace courtyard. When the dancing is at its height two men appear with a long length of royal cloth stretched across the field. The drums roll and the cloth is drawn back to reveal the old princess royal, the chief's aunt, dressed in an old German bandsman's tunic with tarnished silver frogging and epaulettes. She is supported by the new chief's titled uncles. They dance for some minutes: there is a roar of delight from the spectators, in support of their own Royal masks and personages. Then the roll of cloth is drawn back and the group retires into the palace. The Royal dance is over.

THE LEOPARD SOCIETY

For the next dance the Bangwa men who have been drumming are replaced by a group of expert drummers from the neighbouring tribe, the Banyang. The Banyang society *Yangkpe* or *Ngbe* was introduced into Bangwa in the

1930s and has proved very popular. *Ngbe* is the Ekoi word for leopard. In Banyang and Ekoi (Cross River) the society has administrative and police functions: the leopard refers to the fictitious animal which is said to have come under the control of the society's members. The voice of this creature is heard as a mysterious hoot from an instrument which emanates from one of the widow's huts during the performance. Among the mountain Bangwa the Leopard society lacks governmental functions: here it is simply a dance society, an entertainment. Nevertheless it has all the appurtenances of the Banyang society. It is organised into lodges, each lodge divided into graded sections, with an elaborate series of ranks and secret subgroups. The constitution of the society is secret, and its members even communicate in sign language. Its songs are still sung in Banyang. In Banyang the society is 'bought' by groups of villagers: in Bangwa the society is owned by chiefs and administered by their retainers. The chief permits sections to be sold to village heads and nobles. The Leopard society is popular mostly with commoners and young men since the traditional Bangwa hierarchies expressed in the Night and Gong societies are ignored in favour of wealth. The Leopard society in Fontem was bought, section by section, by the chief of Fontem and his sons and retainers became important members. When he had bought it he began selling its secrets and paraphernalia to neighbouring Bamileke chiefdoms, among whom it is proving very popular. In Fontem the paraphernalia of the society and its organisation was under the care of a Banyang retainer at the palace. The society has shrines centred on a stone pillar erected in the Leopard house and vast shields studded with emblems of the society, tortoise-shells, animal skulls, pieces of twisted wire and motley European objects.

The Leopard society is announced by one of the society's emblems swinging from four ropes and carried by four men, their faces yellow on one side, ashen-white on the other (Plate 52). These men wear caps with feathers stuck in one side and, instead of the Bangwa loincloth, a sarong hitched to one side in a typically Banyang fashion. The Leopard noise wails from inside the compound, while in front of the palace-entrance some of the emblems of the society are displayed. The herald dances wildly on to the field. With a curious voice intonation he holds a secret conversation with the Leopard voice, which is pure mumbo jumbo to the majority of the fascinated spectators.

The dance is popular. Young men and women in the crowd begin to tie their cloths in the sarong style in readiness for the dance, which, unlike many Bangwa dances, is open to everyone, including women and even children. The members of the society dance on to the field first, wearing caps stuck with feathers and bell-covered leggings. Some wear cloth over raffia hoops. The first masker leaps through the bushes, greeted by shouts of encouragement from

the dancers. He wears a knotted, skin-fitting suit made of orange, yellow and brown knotted plantain fibre, with raffia ruffs at the ankles and wrists. The figure dances across the field, followed by the others, and disappears at once back into the bushes (Col. pl. 17). The masks of the society have no particular distinguishing features. To some extent they resemble the Royal masks although they are often face, rather than helmet, masks. They are never skin-covered, but are painted brightly and have raffia wigs (Col. pl. 18). These masks are made by Bangwa carvers both for their own societies and for the Banyang. The maskers wear bell-covered leggings and brightly coloured European cloth sticking out from the waist over the raffia-rib hoops. One section of the Leopard society (*angbu*) owns two masks, one female and the other male, which are worn to enact the only miming display to be seen during this Bangwa

Plate 52
Leopard society emblem announcing arrival of maskers

cry. The male figure wears the typical masker's costume while the female one, played by a man, since masks in these all-male societies are worn by men, dons a woman's European dress and apes female mannerisms (Col. pl. 18).

The action is little more than a humorous, constantly repeated, sexual joke between the two of them. They are accompanied by attendants who collect the coins given by spectators and wipe the brows of the masks themselves between the exaggeratedly obscene performances. These two maskers are very popular and the crowd greets them uproariously. When they have danced off the field the Leopard society's performance ends with a free-for-all, the spectators joining in a cheerful, shuffling dance. Some of the younger chiefs join in as well. The older, traditional chiefs declare that the Leopard society is a lot of forest nonsense and an excuse for young men to get together and talk disloyally about their betters.

'MASSEM'

The Leopard society is followed almost immediately by *massem*. This is another society which has been acquired from the forest peoples. It is owned by only a few Bangwa nobles but in a few years it has acquired a great reputation. Its ultimate origins are unknown; but the Bangwa have bought it from the neighbouring Mbo and Banyang. As with so many of these introduced societies, fashion determines their rise and fall. The point of origin of many of them is south-eastern Nigeria and the Cross River area, as can be seen by the style of dancing, music and costume. In many cases the societies which in Bangwa simply act as a means of entertainment, or even ostentation, once served a more serious function at their point of origin. Thus in Banyang the Night society has been imported by some villages, where it is treated as light-heartedly as the Leopard or *massem* societies are in Bangwa and its association with witchcraft and executions is unknown.

The *massem* heralds dance into the field and try to catch the attention of the spectators, who are still somewhat distracted after the exhilaration of the Leopard dance. They consult with the palace police and the latter storm round the field pushing back small children who have broken through the barriers, beating cheekier youths with their staffs – more roughly now after a day's drinking. The crowd is getting more and more disorderly. The chiefs leave their places; *massem* will have to perform without them since they are going to dress for the last dance. The new rulers have been ushered off their dais and have retired to rest in their seclusion huts. The heralds dash back to the dressing sheds and the first figures appear with a flourish. Women come on wearing wrappers and civet-skin cloaks. Young men dance round the field carrying staffs with sprouting leaves and horsehair. The costumed figures appear for a moment.

There is a shout and a man balances precariously on the top of a hut, gesticulates in his gay jester's costume and disappears. Another young man jumps out from the bushes, waving a yellow cloth and skipping across the field into the crowd. Another comes out of the palace courtyard; a large brass bell is tied at his buttocks with a white cloth. He dances around the field, among the *massem* dancers, before leading them off.

Massem is probably the gayest of the masquerades. It does not aim at a highly organised performance like the Royal society's. The costume is body-fitting tights, made of appliqué work stitched on to red flannel, and all kinds of fantasy are allowed in the working of it. Some will tell you that *massem* was a warrior's society and that their costume represented the variegated leaves of the forest and acted as camouflage. When the costumes were dark this may have been true. Today they are a riot of red, orange, yellow and green; in circles, squares, triangles and chevrons (Col. pl. 2). Apart from the hands and feet, which are fringed by red-dyed raffia ruffs, the whole body is covered. The cap has a stiffened horn curving from the back of the head up and over the forehead. The figure suggests gaiety and its skipping dance amplifies this feeling. There is apparently no symbolic significance in the combination of colours and shapes or in the presence of the horn.

THE WOMEN'S DANCES

It is late afternoon. The men are becoming restless and noisy. Now is time for the women's societies. These societies (*ako*) are organised in each palace and village under the supervision of the princess royal or a locally important woman. The chief's wives form one group, distinct from the palace ward or village group. All women belong to a society which meets once every four weeks on a day when the women do not go to their farms. They elect officers. They have a savings society, in imitation of the men's 'meetings', each woman contributing a few francs a time, one of them in turn taking the whole sum.

At their meetings women's affairs are discussed, disputes are settled and grievances aired against their husbands. At a cry their role is important. A kinswoman of the dead man calls upon her group to prepare quantities of food to be taken as her contribution to the feasting. Each *ako* group accompanying a mourner has its own temporary hut at the cry where the food is collected, appraised and redistributed among members and cry visitors.

For the women the main business of *ako* is dancing. They enjoy it immensely and there is always competition at cries to see which of the local societies is the most accomplished and best turned out. Before the death of the late Chief of Fontem, in 1951, Bangwa women wore no clothes. Nowadays they dance in their best blouses, wrappers and headties. Some villages club together and buy

the women matching outfits. Praise-songs about their chiefs and husbands figure largely.

To the uninitiated onlooker the women's tireless and practised dancing appears dull after the wild, and apparently unrehearsed, exuberance of the men. Women dance to a xylophone. This instrument, typically, has seven wooden keys placed loosely on a base of two plantain stems. The players (two or three) sit on either side. The first begins, playing a very simple steady ground-base. The second breaks in with an ornate cross-melody. The drummers join in. The xylophone and drums are an innovation; until recently the women danced and sang to the accompaniment of bamboo pipes. The women enter the field in pairs; some of them wear cross-straps and helmets – they are officials of the society. Titled women carry horsetails. They all wear leg rattles at the ankles. The rhythm is maintained by the captain with a whistle. The music changes; new songs and dances are introduced. The women show their enjoyment by dancing before their friends, embracing happily. A man rushes on to the field and dances in front of a group of his wives – all in the same coloured cloth and wearing the leg-irons which betoken their special status as royal wives.

The first mask comes on. Women wear them, dancing sedately, their skirts held out in hoops, horsetails in their hands. The masks are worn on top of the head or open at the face so that the identity of the women is known (Plate 53). These masks are distinctive, most of them being based on the colonial sun-helmet, brilliantly painted and decorated with pieces of mirror and feathers. They are all modern. Some of the women dance precariously with feather head-dresses. As the maskers appear exhausted they are rudely hurried off the field by the retainers, and new ones take their place. Husbands of the women maskers run on to the field and stick banknotes to their wives' foreheads as they dance across the field. The groups follow one upon the other. The women can continue dancing for hours, but today everyone is in a hurry. Dusk is approaching. The last important men's dance must first take place and the rain expert has prophesied a storm this evening. The last women's societies are rushed through in an uncavalier manner, much to the voiced chagrin of the women.

'ALBIN'

Albin is a dance for the great and wealthy, for chiefs, nobles and their minions. Unlike the Royal society, which performed earlier, its origins are definitely eastern, that is from the Bamileke grasslands. There are no masks connected with *albin*. The men and women dancers (all titled, royals or their servants) wear huge pleated lengths of royal cloth (Plate 54), looped between the legs and splayed out in front and behind into a vast, heavy skirt. The blue and white cloth is often sewn with red pleats and bordered with a band of red felt. Leggings

Plate 53
Women presenting their masks and head-dresses

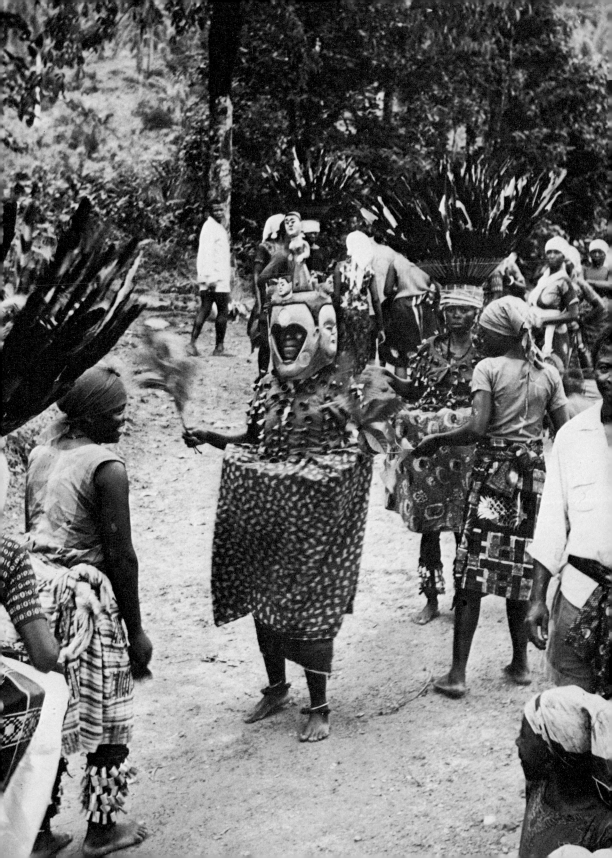

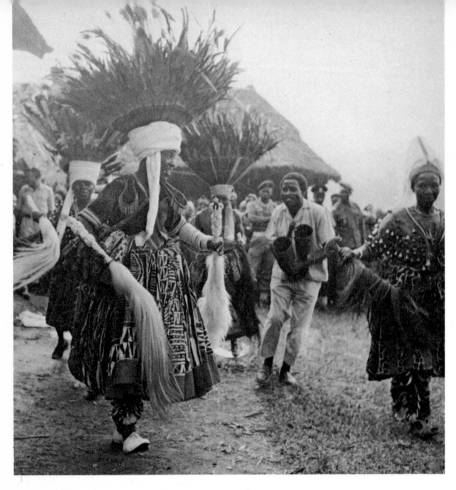

Plate 54
Chief Fontem dancing
albin with ivory horsetail
and bracelet, accompanied
by his princess royal

and waistcoats are worn. All over the palace men and women, helped by
children and friends, are struggling into their costumes. The great glory of
albin is the magnificent feather head-dress, often three to four feet in diameter
and two to three feet high, an explosion of brilliant, multicoloured feathers.
The head-dress is tied on to the head by long strips of material, wound round
its basket-work base. These head-dresses are made by experts and represent
weeks of patient work (Plate 55; Col. pl. 6).

Meanwhile the members of the Gong society have secretly removed the instru-
ments from the sacred copse and placed them inside a moveable, square screen
behind one of the widow's huts. The players stand inside this large, cloth-
covered box awaiting their orders. When the *albin* dancers are ready, the contrap-
tion is lifted by four men and taken through the crowd into the middle of the
field. The musicians are silent until the word is given by a servant and the
splendid music of the gongs hushes the noisy crowd. At the same time three
young men leap into the field wearing leopard skins on their backs, make formal

Plate 55
Albin costume

114

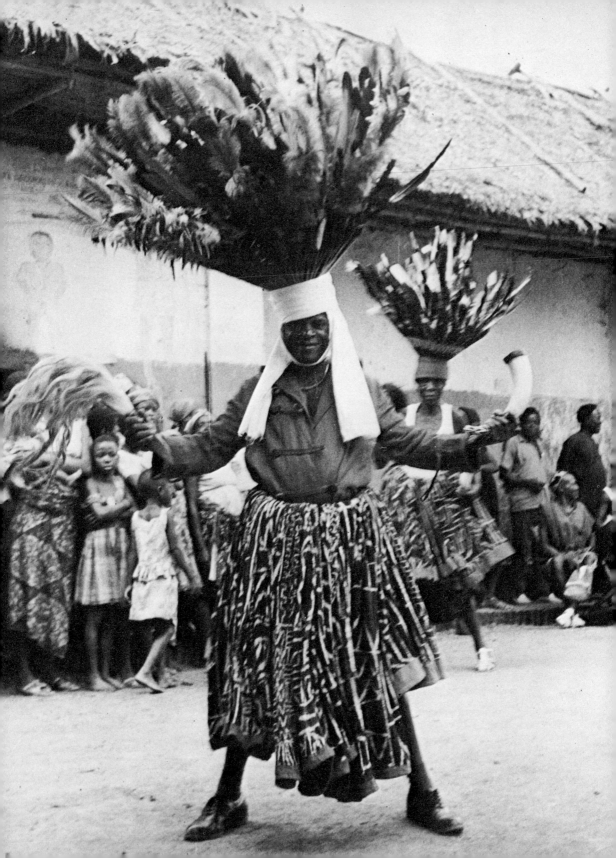

obeisance before the chief and place the skins on the ground before him. Following the leopard-men come the chiefs themselves. One carries a beautiful ivory-handled fly-whisk, intricately carved (Plate 23). Others carry horsetails the handles of which are carved and sometimes beaded.

Paramount chiefs are flanked by servants or titled siblings who shout their praises and encourage their subjects and wives among the spectators to ululate. The crowd roars in appreciation of the display. Some rush into the field and press money into the hands of the dancers' servants. Others mop their brows with cloths. After the great chiefs come minor nobles then hundreds of men and women, wearing the huge swaying skirts and the tall spectacular head-dresses, enter the field, dancing to the gongs, forming a circle round the musicians in their box draped with blue and white royal cloth. The dancing is impressive. It is not boisterous, but with an elegant, subtle rhythmic movement of the shoulders and a gentle prancing of the feet. It is a splendid finale to the day's performance. But after a few minutes the music stops. The dancers leave the field and disperse inside the palace, followed by the shrouded figures in the royal enclosure. Without any ceremony the cry is over. The crowd stays for a while in the field, or spreads into the empty market-place to chatter and discuss the day's events. Children are sent to collect parcels of food wrapped in leaves; empty wine jars are lifted on to tired heads; and small processions start up or down the innumerable paths which surround the palace.

Palace retainers remove the cloths and decorations from the dais and take in tables and chairs, the Toby jugs, the tattered Union Jack and the Cameroon flag. The carved statue of the dead chief, standing outside the sacred copse, is carefully wrapped in sacking and taken back to its place in the skull-hut. The rulers are back in their own seclusion huts; here they will remain for nine weeks, being continually rubbed with the potent camwood-oil mixture and learning the secrets and business of chiefship from the country's elders and the members of the Night society. The widows, tired from a long day's wailing and dancing, retire to their beds of dried plantain leaves on the floor of the meeting-house. The palace grows quiet. Suddenly there is a wild hooting, like the sounds that began the cry early that morning. The servants of the Gong society are returning the gongs to their house. Women and children left in the large courtyard flee to their houses, laughing, while the men run through the palace bearing the covered gongs and rattles on their shoulders. They shout and laugh, and disappear into a far gateway. The women come out of their houses again. It is now quite dark. There is a crack of thunder and the rain comes as the domestic life of the palace takes over from the public ceremony of the royal crowning and funeral.

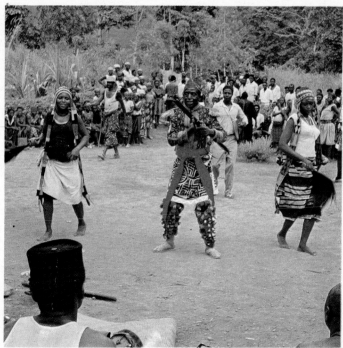

Colour plate 20 Subchief with his titled sisters presenting a masquerade

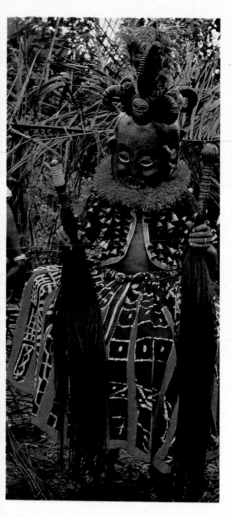

Colour plate 19 Royal masker

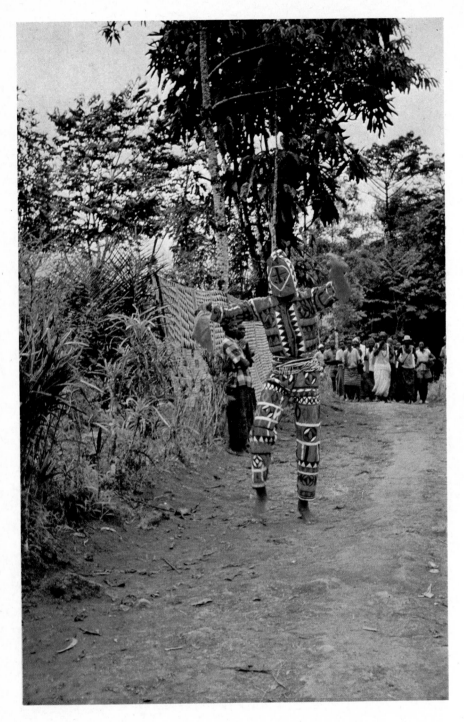

Colour plate 21
Massem masquerader

CHAPTER FIVE

Portrait statues, fetishes and Night masks

Three of the art forms which feature in the cry are so important that they merit description in greater detail. The first, the portrait statues, appear in public only on the occasion of a chief's death or coronation or during a performance of the Gong (*lefem*) society. They are portraits of royal ancestors: not only of the chiefs, but of their mothers, princesses royal and occasionally a titled brother, a favourite royal wife or an important retainer. Included among the *lefem* figures are the one or two remaining examples of statues by Bangwa, statues depicting priests and priestesses of the earth (the fathers and mothers of twins, *tanyi* and *anyi*). Fetishes, on the other hand, are more expressionistic figures carved for the use of anti-witchcraft specialists. They are invoked to prove or disprove the guilt of an accused witch. They appear at the cry to protect the new chief and the compound generally against the depredation of evil-doers during the ceremonies. These fetishes are believed to attack guilty persons by acting autonomously through their own powers. Their servants (the ritual experts of the *kungang* society) merely direct the performance of the associated rites. Third are the Night society masks which are generally of an abstract nature and invoke terror in the Bangwa who associate them with the harmful aspects of this secret society's functions. They appear at the cry as a symbol of the Night society and are placed before the seclusion huts of the new rulers and the Night society hut itself which completely separates these tabooed areas from the public arena of the cry (Plate 8). Of these three art forms only portrait figures have yet reached European and American museums and private collections

in any great number and they are very different in conception from the masks of the Night society and the distorted, often zoomorphic fetishes.

PORTRAIT STATUES ('LEFEM' FIGURES)

The *lefem* figures are primarily portraits of ancestors (Fig. 26). They embellish the Bangwa ancestor cult and act as concentrated symbols of a dynasty's power and history. If a Bangwa chief has seven skulls, he has seven patrilineal ancestors, and he therefore should also have seven wooden portraits of these ancestors. Only a few Bangwa chiefs claim to have a complete set and at the present time these memorial figures are very rare indeed. Many have been allowed to rot away (Col. pl. 1); others are lost in fires. Today the high prices offered by European collectors tempt the chiefs to sell them. In some cases a figure which has been sold or destroyed is 'recarved' to add to the collection. In others, chiefs who have recently acquired wealth and power commission a sculptor to make up an ancestral 'set': this is clear from the homogeneous style of some sets of memorial figures. As far as we could determine, none of the nine paramount Bangwa chiefs in 1967 had a full set of figures. The chiefs blame this state of affairs on the destruction of their palaces by the Germans in the early 1900s. At great cere‑ monies *lefem* figures are borrowed from lesser nobles and, by a kind of subter‑ fuge, converted into the appropriate ancestors. It is clear therefore that much of the splendid sculpture illustrated in this book is not the property of mighty paramount chiefs. Bangwa is a scattering of miniature chiefdoms; within a chiefdom of a few thousand people, there are subchiefdoms based exactly on the pattern of the suzerain chiefdom. And within a subchiefdom of a few hundred people there are nobles who organise their tiny hamlets as near as possible along the lines of the subchiefdom. Some of the grand royal portraits belong to a chief or lord whose subjects may number less than two dozen adult males, most of whom are his own patrikin and descendants of his retainers. In other cases a noble who rules himself, an old servant and a compound of wives and children may have a complete collection of ancestor figures and Night masks – relics of past glories.

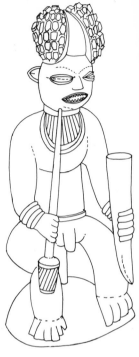

Figure 26
Ancestor portrait

The ancestor figures are not shrines. They are memorials to the dead, rather like effigies in an English church, or on Etruscan burial urns. The Bangwa ancestral shrines are the skulls of past chiefs; it is the skulls and not the statues which are fed in times of misfortune and through which the Bangwa are brought into direct contact with the world of the dead. Nevertheless the figures are not just works of art. They are treated as persons, called by name and deemed to possess the character of the original sitter. Handling them involves ritual precautions; they are usually cared for by a special retainer to whom the chief makes specific payments when they are brought out for use. Myths grow up

118

round them; one set is believed to have stolen a complete German brass band from a distant rival chief to add glory to the cry of a princess royal.

The Bangwa sculptor has many opportunities for exploring abstraction but this is not found in the ancestor figures, which are intended as realistic portraits. The figures average three and a half feet in height. Chiefs are typically shown seated on a royal stool which itself is often intricately carved. There is a less common, smaller standing figure which is carved on top of a mace associated with the Gong society (Col. pl. 10). In the carvings the values of chiefship are reflected. They exhibit an imposing elegance; a bangled arm rests on a naked knee, the other hand supporting a contemplative chin; a broad, smooth brow spreads back from almond-shaped eyes. In these representations is seen both the serene power of the chiefs, and, in the elaborate detailing of ornament and cloth, their great wealth.

The chief is carved in ceremonial dress – as he would appear at a performance of the Gong society, or when ready to receive an important visitor. He wears his most valued 'king-things'. The head-dress, a close-fitting skull-cap, made from woven plantain fibre, is coloured white, indigo and red. Sometimes the royal cap is made like a porcupine, with little covered quills sticking out all over the head. A more common design is a cap with sprouting reinforced cones, each two or three inches long. The chief is invariably shown wearing a necklet of royal beads. The most famous is a tubular, yellowish bead which is reserved for the use of chiefs and their princesses royal. These beads are worn in a series of torques around the shoulders and neck. This type of bead is placed, one in each of the chief's nostrils when he is buried. The chief sits for his portrait wearing leopard-skin anklets. His arms are sometimes encased in ivory brace-lets made from a single elephant's tusk. In his hands he holds a calabash or a drinking horn or a pipe. These pipes are elaborately moulded of clay or brass (Plate 13). They have enormously long handles; in public the chief smokes in regal fashion, with an attendant retainer crouched low on the ground to keep the pipe alight and filled.

The chief wears the traditional loincloth, knotted at the waist and drawn up through the legs from behind and allowed to hang in folds over the crutch. The cloth is the blue and white 'royal cloth' imported from Nigeria. The Bangwa say the older statues show the chief wearing local bark-cloth. The loin-cloth is carved with five or seven folds, according to the rank of the chief. In other statues, the chief is shown naked; the genitals are not exaggerated but carved realistically (Fig. 27). Naked figures usually wear a leopard-skin belt.

A fine example of an ancestor memorial is illustrated in Fig. 27. The subject wears the royal 'bobble' cap, beads, bracelet and leopard ankle-straps. In his left hand he holds an elaborate pipe, in his right a calabash of the type used in

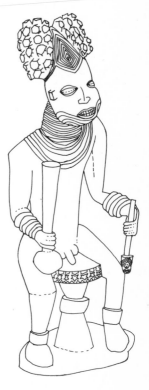

Figure 27
Ancestor portrait

119

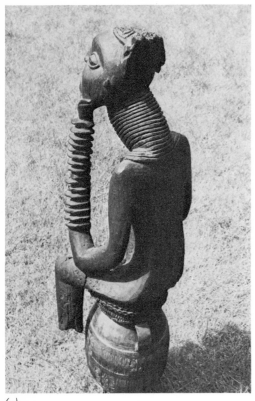

(a)

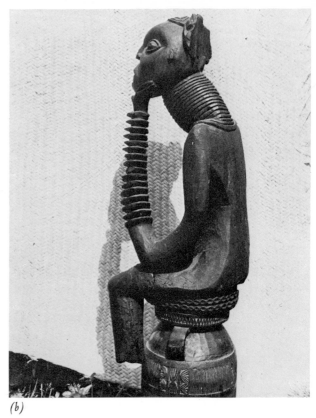

(b)

the Gong society. There is an enjoyment of linear decoration evident in the head-dress, stylised beard and collar of beads which is also characteristic of some of the Night society masks. The torso is a straight trapezium without rib-cage. The eyes are set between two rounded discs suggesting the brows and cheek-bones.

Portrait figures show features which distinguish them from all other Bangwa sculpture. First and foremost they are meant to portray royalty. They appear on view during the cry or a performance of the Gong society where they can be viewed from all angles by interested onlookers. They do not, as do the masks for example, appear only for a brief moment during the turbulent atmosphere of the dance. As we have said, they are shown inside the sacred copse. One is placed outside in full public view (Plate 57). Another may be placed beside the veiled rulers in their enclosure on the dancing field. They are seen from all directions and are meant to be impressive from front, back and sides (Plate 56a–c). But even in this class of representation which might, at first glance, appear to be exclusively concerned with the formal expression of a static symbolism, there is also an

Plate 56 a, b, c
Ancestor memorial supported on an oil pot, with ivory necklace and bracelets similar to those worn by Chief Fontem in Plate 54

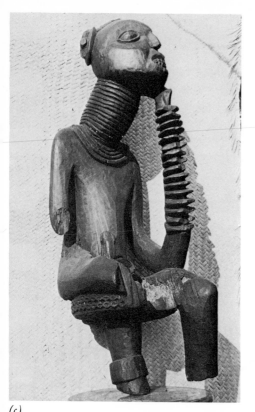
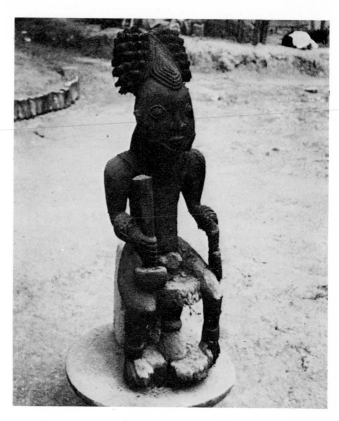

(c)

emphasis on the individual concerned; there is often a twisted head or a bent shoulder which is intended to betray the human individual inside the royal ancestor. The head is given particular treatment, often being carved out of scale (Col. pl. 9). One is immediately aware of the expression, particularly of the eyes.

The important feature of these carvings is that they are intended to show likeness: the sitter's features, expression and stance. The paraphernalia has to be shown but is of secondary importance. Modern carvers, untrained young men, concentrate on the ornaments worn by chiefs and neglect to portray their sitter's individuality. In many cases they carve from memory. And, today, unaware of the significance of the symbols, they carve royal wives with drinking horns (reserved for men and princesses royal) and chiefs with women's anklets.

There is a tale told of a famous sculptor which is repeated whenever Bangwa elders wish to decry the lack of individuality expressed in recent portrait statues. It concerns the carver of the figures in Col. pls. 9, 10. With the permission of his chief, Fontem, he accepted to carve the likeness of a Banyang chief who lived on the forest border and controlled an important market visited by the

Plate 57
Ancestor figure

121

Bangwa buying slaves and oil. The Banyang chief, impressed by the hier-
archical political institutions of the Bangwa, had adopted many of their institu-
tions and determined to have a *lefem* figure as well as the gong music. The sculptor
travelled down to the forest from Fontem and spent several weeks in the chief's
compound working on the figure. He worked in seclusion, enjoying the
benefits of Banyang hospitality and carving his host from life. When the sculp-
ture was finished it was wrapped in bark-cloth and placed in the corner of the
hut where he had been working. Demanding his payment (a female slave)
he asked the chief to promise him not to look at the carving until that evening.
Then he left the village with his booty and climbed the precipitous paths to
Fontem, 2,000 feet up the escarpment. That evening the chief impatiently
removed the figure from its covering; the assembled villager elders found a
statue perfect in all detail, including the chief's ugly lop-sided mouth. A chase
was made, but the sculptor and his 'wife' had reached the safety of the Fontem
palace.

Although traditional symbolic forms do, of course, limit the initiative of the
carver, artistic individuality is expressed in the portrait figures. In some cases
the identity of the carver of a group of statues is known, but generally it is not.
The developed style shown in Plates 2 and 31 seems to betray the hand of a single
artist, particularly when a close comparison is made between the two male
figures. Cap, drinking horn and collar are identical. The faces, however, are
different; they are carved from life and resemble their subjects. The statue illus-
trated in Plate 32 is similar again; but here a sculptor's general style has been
imitated by an amateur of less skill. The fetish illustrated in Plate 12 is an
important comparative case. The figure has been executed in a similar style,
whether by the same carver is not known, but with a very different intention.
The features of the fetish are zoomorphic, particularly the ears and eyes; the
body has been given the swollen stomach and bent knees which are standard
features for this type of carving.

Another group of figures (illustrated in Plates 20, 56, 57) may have been the
work of one carver. The carver who is the hero of the tale about the Banyang
chief left behind a series of figures and one or two Night masks which are
scattered throughout Fontem. His style is recognised by the Bangwa today
although he has been dead for over half a century. The style of his work fits
well within the bounds demanded for these royal statues, but the hand of this
particular sculptor is clearly to be seen. His work has a vitality which many of
the other figures, somewhat formal in their chiefliness, lack. The statue illus-
trated in Col. pl. 9 is typical. It is carved in strong swelling lines, with rib-cage
clearly shown; primarily of a man of action. His costume is not elaborate.
There are no beads. The stool on which he sits does not have fine decoration,

nor does the chief hold an elaborate pipe. The sculptor is evidently interested less in royal paraphernalia than in the individual and his personal vigour. In Plate 57, however, the symbols of chiefship and the care devoted to the finesse of their carving, play as important a part in the chief's portrait as the man himself. Another figure claimed by the Bangwa to be by the same artist is shown in Col. pl. 10.

Female figures exist within the general category of portrait statues or *lefem* figures. Strictly speaking, memorials would only be made for a chief's mother, for only direct ascendants are worshipped in Bangwa cults. Only rarely do their custodians declare the female figures to be 'mothers' (ancestresses). One case is illustrated in Plate 59; the subject purports to be the founder of a patrigroup of which the owner is the present head. However, although mothers are granted great respect in Bangwa and play an important part in the matrilineal skull cult, they are not involved in the Bangwa ranking system while alive. The Bangwa do not recognise 'queen mothers'. Female titles are held rather by the chief's sisters; as has been seen, they are called *mafwa* (literally 'female chief', but trans-lated here as princess royal) and *angkweta* (female *nkweta*). These royal princesses are portrayed usually in the costume of a chief, wearing a man's loincloth and carrying either a pipe or a drinking horn. Titled women of royal lineages appear on ceremonial occasion in clothes borrowed from their brother, the chief; they have the right to wear paraphernalia usually reserved to men. Portraits of women other than princesses characteristically show them naked.

Examples of other female figures are illustrated in Plate 2 and Fig. 21. These are ranking wives of the chief. There are two important title-holders among the royal wives – the chief's first wife and his favourite wife. The former has an administrative role within the palace, seeing to petty squabbles between the wives, while the latter's influence extends outside the palace – she may attend royal councils, travel with the chief, even attend sessions of the Night society. Portraits of royal wives of both these ranks are carved. The style is similar to that of the royal princesses in that they both wear hairstyles which are forbidden to commoner women and bead necklaces. However they are shown with ob-jects associated with the wives – a calabash to fill their husband's drinking horn and a bamboo flute, used in dances reserved to royal wives.

Included among *lefem* figures by the Bangwa are figures associated with the cult of the earth (*ase*), whose priests and priestesses are the parents of twins. In fact they function quite differently from the ancestor memorials. Many of these statues, including Plate 20 and Figs 15 and 21 are now in European or American private collections and museums. Only one Plate 20 (since sold) was found in Bangwa in 1967 and it was therefore very difficult to unearth any reliable information about them. Some Bangwa declare the statues of women

123

and children to be portraits of royal wives; but this can only be substantiated by the presence, or lack, of royal anklets. Others, even when holding one child, are said to be *anyi*, mothers of twins. The title of *anyi* is given to a woman who has given birth to twins or one 'special' child – one born with a caul, with six fingers or by breech birth. Many of the women dancing *ase* at the beginning of the royal cry are mothers of 'special' children, not necessarily twins. This fact, coupled with the technical difficulty of portraying two children at the breast, lends support to the theory that these mother-and-child figures may in the past have been intended to represent mothers of twins. There is little doubt about those shown wearing cowrie-shell necklaces and wristlets. (In Bangwa cowries are the attributes of twin mothers; in Bamenda and Bamileke, however, they are also worn by royal wives, usually in the hair.) There is also a statue of a father of twins, *tanyi*, flanked by children, one of either sex. This was brought back from Bangwa at the turn of the century by Conrau. A curious feature of this carving is that the twins are carved as little adults; the boy wears a cap and the girl a necklace. Only their swelling stomachs and comparative size indicate their 'childishness' (Fig. 20).

Perhaps the most well-known of all Bangwa works, which has appeared in innumerable works on primitive art is another 'mother of twins' which was brought back by Conrau in the 1900s (Plate 58). Conrau records that the Bangwa called her *njuindem*, which literally means 'woman of God' and refers to the role of certain gifted mothers of twins as diviners. The titles *ngwindem* (or *njuindem*) and *anyi* are used interchangeably. One *ngwindem* in Bangwa today divines with cowrie shells or while in a state of trance. While singing and dancing *ase* (the song of the earth) she carries, like the carved figure, a rattle in her right hand; in her left she carries a bamboo trumpet of the kind used for calling the gods. This statue of a dancing woman, then, portrays a mother of twins in her role as priestess of the earth and witch-finder. A comparable statue may be the one illustrated in Plate 59.

The style of the ancestor figures and those of mothers and twins are essentially similar. The fine seated figure (Plate 20) carved in the typical lively tradition of these figures, shows a mother looking up while giving her child suck. She wears an *anyi* necklace (leopards' teeth hanging down the back of her neck) and wears her hair in a fashion said to be formerly reserved for mothers of twins. Figure 15 is a drawing of one of several Bangwa mother-and-child figures which have been reproduced in Kreiger. It shows a woman, wearing a cowrie necklace, with a child, typically carved like a medieval Christ child, as a small adult. The Bangwa name in the catalogue is again *ngwindem* 'woman of God'. Unusually the sculptor has left out the woman's breasts. These figures of mothers of twins are portrayed in a generally similar style but again there is

Plate 58
The most famous piece of Bangwa sculpture – a dancing figure – formerly in the Helena Rubenstein Collection – sold in 1960 for a record price. Now in Harry A. Franklin Galleries, Beverley Hills, California

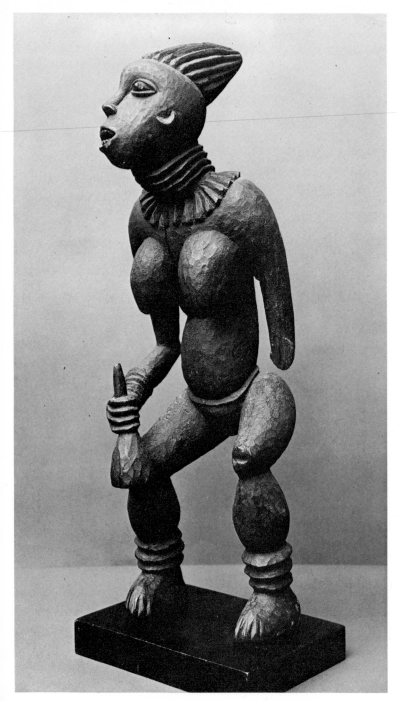

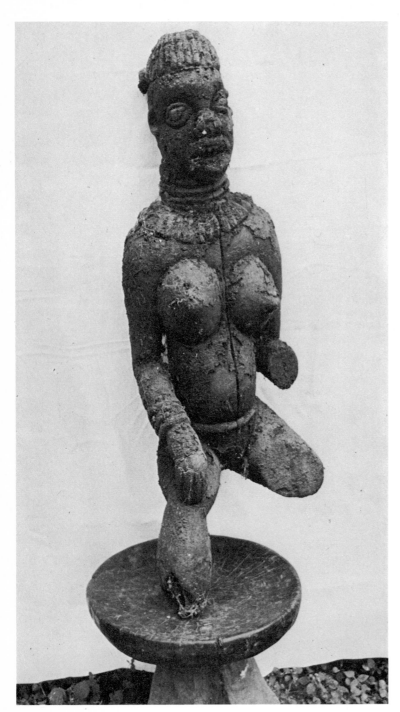

Plate 59 Female figure

wide variation in form as well as in the detail. It is interesting to note the difference between the angular style of the seated woman with her child (Plate 20), particularly the triangular breasts, and the more sensuous, rounded form of the dancing figures (Plates 58, 59).

All the *lefem* figures, however varied in subject or style, share the element of portraiture noted for the ancestor portraits. None of the mother of twins figures lacks liveliness – eager heads stretched slightly forwards as if the sitter is determined that the carver should not miss her own, particularly personal expression. Yet there is, as in all art, much stylisation. Ears are oblong or triangular shapes. The breasts are carved as globular additions or flat triangles. Almost invariably the heads are given greater prominence than the rest of the body. However, it is with the fetishes that symbols, represented by an exaggeration or stylisation of parts of the body, come to dominate the statue.

THE FETISHES

Bangwa fetishes, owned by ritual experts, are of two general kinds. First and most common, are the *njoo* fetishes. They are malformed, anthropomorphic figures containing powers invoked by ritual, which protect individuals' compounds from the attacks of witches, thieves, even adulterers. The figures are usually small and shown with bent legs. They may be carved by amateurs in a few hours. They are naked, without ornament, although sometimes pieces of red and black cloth and a string of beads are added during medication (Plate 60). They cause minor illnesses and their effects, revealed by divination or confession, may be revoked by a ritual performed by their owners. Unlike the *lefem* figures, it is the functional success of these figures which the Bangwa comment on, not their appearance; they are considered to lack aesthetic merit.

A second, more important type of fetish is the *lekat* figure associated with the loose-knit *kungang* society which is Bamileke rather than Banyang in origin. The *lekat* fetishes are larger (up to four feet in height). They are carved with greater care and are usually old. Examples are shown in Plates 12, 61 and Figs 7, 8 and 28. They are powerful agents capable of harming witches and other criminals. The swollen stomach indicates the dreaded dropsy, which is one of the supernatural sanctions of the fetish and affects the evil-doers. The symbolism involves sympathetic magic: if you attempt to harm your kin this is what will happen to you. This explains much of the symbolism which differentiates them from the royal portraits or the figures of the earth-cult. Nevertheless there are features in common which indicate that the same carver may have made ancestor memorial, Night mask and fetish. In the fetish, symbols associated with witchcraft and punishment have replaced those linked with royalty or

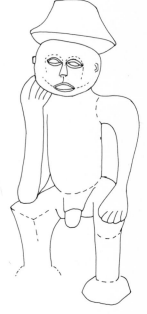

Figure 28
Fetish figure

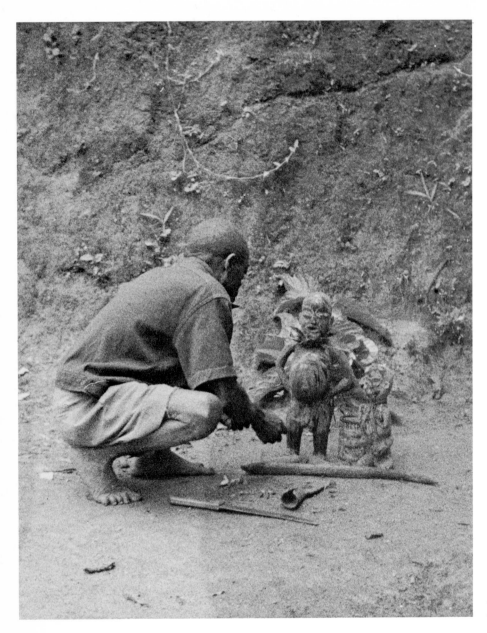

Plate 60
Njoo fetishes during rite

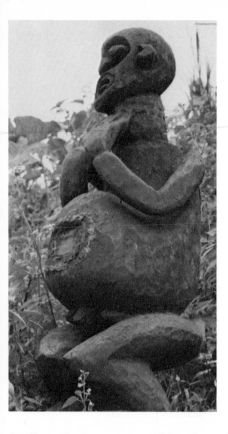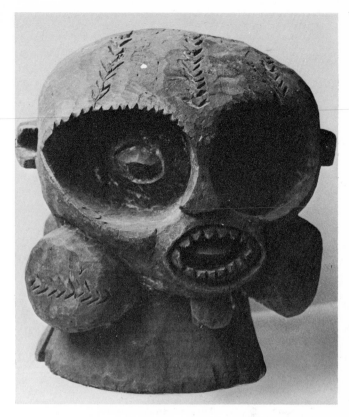

fertility. The bent arms and hands to the shoulder, in the fetish, represent the attitude of a begging orphan or friendless person. The crouching position is the stance of a lowly slave. In the same way, although different in form, the carving of the large *lekat* fetish illustrated in Plate 61 is reminiscent of the type of Night society mask shown in Plate 62.

Unlike the *lefem* figures the fetishes of the *kungang* society are in constant use today. Most of the figures have a small panel in their stomach or back which can be opened for the insertion of medication. Such figures have a thick patina from the blood of chickens sacrificed during oathing rites. Once misfortune has been attributed by the diviner to an individual or group of persons, he or they are forced by the chief to take an oath of their innocence in front of the fetish. A simple rite is performed in the palace by the *kungang* priest, so that the fetish may bring its supernatural sanctions to bear if the accused lies. As shown in Plate 12, the fetish may be accompanied by a dog, which precedes it, flying through the air to hunt out the witch.

These *kungang* fetishes play an important role in the beliefs of the Bangwa

Plate 61
Fetish figure with the swollen belly of its dropsy victims

Plate 62
Two-sided Night mask

129

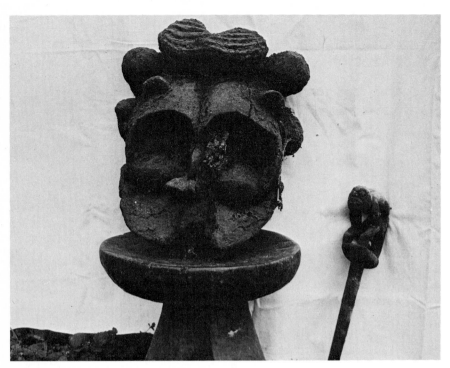

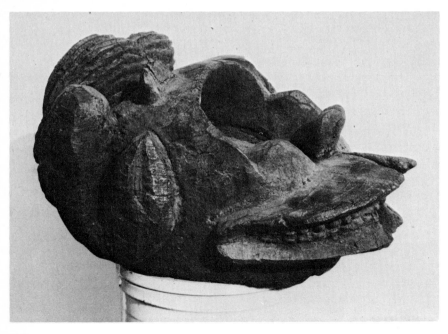

Plate 63
A Night mask before
cleaning, with small
Night staff

Plate 64
The mask, from a
different angle after
cleaning

people. Unlike the *lefem* figures, they are rarely sold to outside buyers. The chiefs are not convinced that the medication of a newly carved fetish figure would adequately replace the old ones. It seems that their powers are believed to have accumulated over the generations and no new carving can be expected to equal them in potency. Much more than ancestor worship, witchcraft is still a force in Bangwa religious beliefs.

NIGHT SOCIETY MASKS

While most of the masks associated with the dance societies which perform at the cry are in Bangwa eyes primarily works of art, beautiful and exciting objects which are used in the masquerade with panache to sustain the festive atmosphere, no Bangwa would attempt to give an aesthetic appreciation of the Night society masks. Masks of the Royal or Challenge societies are applauded or denigrated by the spectators, and their aesthetic value is rewarded materially by the gift of coins to the masker. But Night society masks are awe-inspiring, terrifying symbols of the worldly and supernatural powers of the chiefs and his servants (e.g. Plates 64 and 65).

The inner sanctum of the chief's Night society has nine members, known as the Nine; a subchief's has seven. This explains the statement that the society should own nine masks (or seven in the case of a subchief). The masks are symbols of the power of the chief as expressed through his secret regulatory society. The masks themselves, while in no sense fetishes, are dangerous. They are stored, not in the palace where they might harm the chief and his family, but in the huts of menial servants. They are moved only after those who come in contact with them have taken strict ritual precautions. The chief himself, pretending greater fear than his subjects, refuses to touch them. An outsider who comes into contact with an important mask will, it is believed, suffer such automatic afflictions as blood-spitting and dizziness.

Night masks are unadorned with mirrors, skins, feathers or paint. Years of accumulated soot and libations give them a thick patina which, the Bangwa state, adds to their effectiveness as emblems of the Night society. The patina detracts in some cases from the original intentions of the carver; in Plates 63, 64 we show an example of the same Night mask before and after cleaning. In some of the cruder examples the sculptor may have carved with its future encrustation in mind.

Since many of these masks were carved to be worn on the head, with holes for raffia veils, it is assumed that they were once so worn. However, today they are said by the Bangwa to have acquired such powers that it is too dangerous for them to be placed on the head, the part of the body most sensitive to mystical danger. Even to carry one on his shoulder a man must be of a certain status

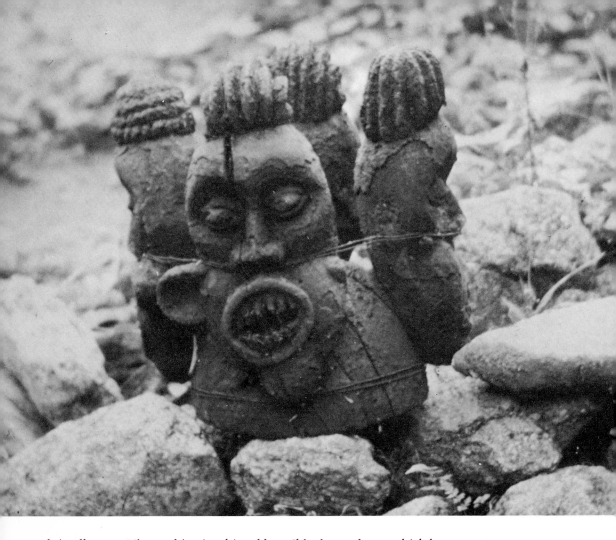

Plate 65
A four-headed
Night mask

and ritually pure. The masking is achieved by a filthy knotted cap, which hangs bedraggled over the shoulders and which is made from a worn-out tadpole net used by women, but not, it is said, recognised as such by the Bangwa spectator. The Night society masks appear as emblems of the cult and in this way they are quite distinct from other masks used in the cry spectacles. One Night mask is placed on the ground outside a palace hut where the Night society meets during the cry. It is covered with large, soft Night leaves (Plate 8). For the Bangwa it is an object of fear; it has a contained energy which immediately transmits itself to passers-by. As instruments of social control the efficacy of these masks is startling.

Witchcraft beliefs partly explain the horror in which the Night society's masks are held. The chief and his retinue achieve their transformation into leopards, elephants, rainbows and chameleons through the medium of this

set of masks. The worldly activities of the Night society also add to the atmo-
sphere of fear surrounding the masks. Its members are state executioners, and
in the past hanged witches and criminals. Public appearances of the masked
members are arranged in a theatrical manner. Their movements are weird and
indecorous; their costumes are meant to terrify – and they do. The language of
the masker is full of esoteric allusions, which are only half-grasped by the
onlookers. Their voices are altered to a weird guttural. Even today, the passing of
a single Night figure on an innocuous errand for the chief sends panic to the
heart of a person who happens to meet him on the path. In the past, there were
midnight meetings of the society, each member attending daubed in red
camwood and white chalk markings. These meetings, linked in the public
mind chiefly with witchcraft, are held in the palace, under the protection and
inspiration of the society's masks.

The symbolism of these masks is evident. Bared teeth, blown-out cheeks,
overhanging brows – all transform the human being into a supernatural one,
its features distorted with lust or fury. The masks are explicitly said to represent
humans not animals, in spite of the fact that they are so closely associated with
beliefs in animal metamorphosis. The grotesque abstractions of the features,
particularly in Figs 37–40, might lead one to think that they are depicting
were-animal concepts, but this is not so, for, according to the Bangwa, they are
all men, terrifying, powerful men. The Bangwa point to the nose, eyes and
mouth, which despite distortion are decidedly human. Features are exaggerated
and moved around the face in order to stress the supernatural attributes of
Night society members. The blown-out cheeks are a good example. Most
Bangwa say they are carved in this way to frighten women and children.
Others perhaps, say that they are so made to make a poor man laugh, so that
he will be forced to pay a fine to the society. Others point out that fat cheeks
are a sign of wealth and power; great chiefs are always fat of face.

The masks of the Night society are astonishingly varied in form. Most of
them show an extreme, even violent abstraction which corresponds to their
role in inspiring terror. But a few are not alarming to the outside observers but
reveal on the contrary the royal calm associated with the portrait statues. It is
interesting that these are considered the oldest, but otherwise there is absolutely
no information about them. In style they are also reminiscent of masks from
central Bamileke, even Fumban (Fig. 14). Despite their similarity to the
faces of the ancestor figures, they inspire in the Bangwa the same feeling of awe
and dread associated with the more typically abstract masks.

A detailed study of a series of these Night masks has been made here to show
that there is a common theme running through them all: the power of the
chief. The illustrations (Figs 29–47) have been arranged to show a progressive

133

Figure 29
Night mask 1

Figure 30
Night mask 2

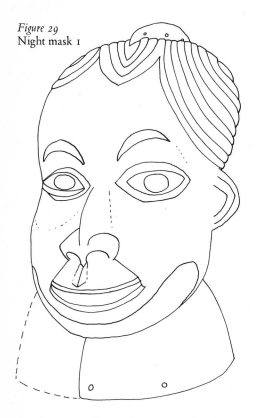

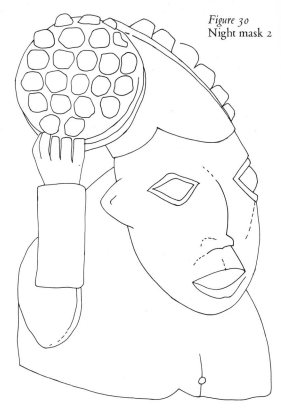

development from the portrayal of a serene chief into that of a terrifying, supernatural being. The arrangement is not chronological.

Mask No. 1 (Plates 28, 29) in this series was originally discovered with a very thick layer of dirt, lying forgotten in the compound of a subchief whose ancestor was a retainer of a chief of Fontem. The only stylisation is the line round the chin, representing a beard, and a three-part hairstyle. When this was pointed out to the Bangwa they immediately called it a Night mask; at the same time they declared it to be strangely like a recently dead elder. It has a benign, smiling mouth typical of the *lefem* figures and none of the expressionistic features of the abstract terror masks. The whole head is set at an angle, thrust out on to a widely curving neck. Similar poses are found in the portrait statues. Mask No. 2 has much in common with the first except that it has a hat, instead of hair, held on by small hands. Masks Nos 3 and 4 have similarly realistic features. They are given beards; holes in No. 3 are presumably to attach raffia veils.

Mask No. 5 (Col. pl. 2) is the largest. Both size and expression make it the most imposing example of a serene, naturalistic portrait of a chief. In style it is again akin to the *lefem* figures. The eyes are elongated; there are no eyebrows.

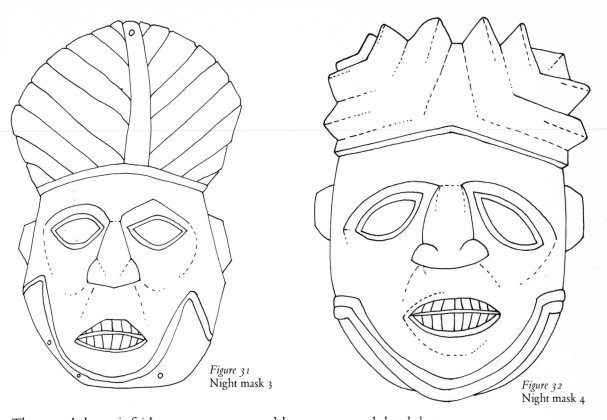

Figure 31
Night mask 3

Figure 32
Night mask 4

The smooth brow is fairly narrow, surmounted by an open-work head-dress. The wide, drooping mouth lacks the commonly benevolent expression given to chiefs. There is a slight trace of a beard line as if the sculptor changed his mind half-way through. The head-dress is carved with two chameleons, on either side of a ribbed, central band which may represent hair. The chameleon is an important symbol: members of the Night society are believed first to transform themselves into a chameleon before assuming the important shape of an elephant. To the ordinary Bangwa the chameleon is the most fearful and taboo animal. Possibly the chameleon symbol replaces the surrealistic treatment of the facial features in other Night masks.

The rest of the illustrated Night masks become more and more terrifying and less and less naturalistic. They are carved with two faces, two mouths, several eyes, huge overshadowing brows or extra ears sprouting from the side of the face or the forehead. In some, the mouth shoots out on a different plane from the rest of the face. Teeth flare out of a vast cavity, tongues protrude like gargoyles. None of these features are found on the previous masks, nor on the *lefem* figures. They do, however, appear on the Night society sticks and the anti-witchcraft

135

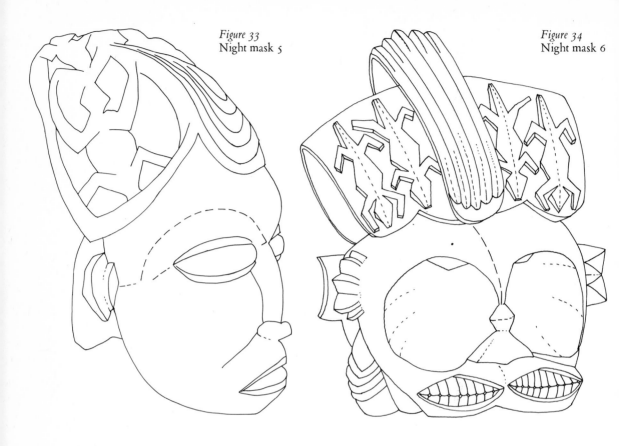

Figure 33
Night mask 5

Figure 34
Night mask 6

fetishes. Mask No. 6 is similar in carving to No. 5 with a high head/dress, incorporating chameleons. They are similar, but in the second, simplicity has given place to complexity and fantasy. The central hairpiece of the head/dress has become an enveloping band. The carver has formed the face of two circular shapes, meeting at the nose, which is made up of three triangles. In the circles he has hollowed out deep cavities forming dark overhanging brows for the cut out eyes. This mask has been given two mouths and two chins. The ears have multiplied. There is another face carved at the back: it is said that, since the Night society are the 'eyes' of the chief, its masks should be two/ or four/sided to allow the society to see in all directions. In some masks two faces are fully represented on one plane. Perhaps the sculptor took the concept of a Janus mask and incorporated the idea into a single/faced mask.

Mask No. 7 shows this clearly. The artist has used elaborate decorative

Figure 35
Night mask 7

Figure 36
Night mask 8

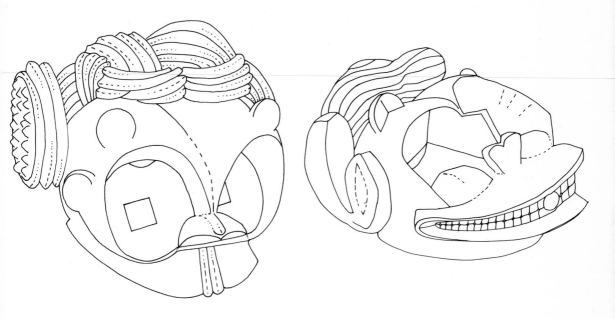

techniques to indicate hair in the centre and a royal cap (or segments thereof)
on either side. In this mask ears appear over four eyes. Under the lip, which
comes out like a shelf, with fluting down the centre, are two mouths. Here we
have an example of duality expressed frontally. The cap and the hair are divided,
the cap being taken to either side of the head. The features are doubled in
the same fashion as the preceding mask. Mask No. 8 (Plates 63, 64) is a
little smaller, but very similar. Here the cheeks are shown as two hemispheres
laid on the same plane as the lips, which curve around the head. Hair is again
arranged in the centre of the head. The ears are two chevron-shaped rolls on
the sides, with two subsidiary ears over the brows. This mask has only one
set of teeth. In the centre of the mouth is a hole whose significance is not
known. Two masks (Nos 9, 10) show further developments. Here is the same
mouth treatment as in the two preceding masks. The brows are shallower; the

137

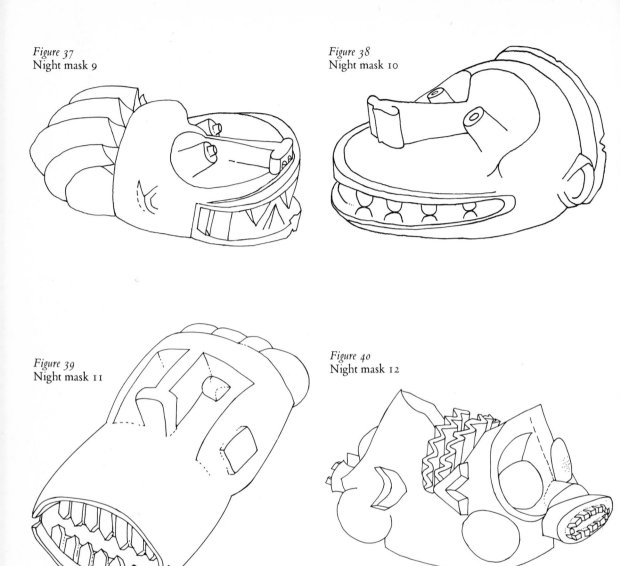

Figure 37
Night mask 9

Figure 38
Night mask 10

Figure 39
Night mask 11

Figure 40
Night mask 12

eyes are not lost in the shadows of deep-cut brows but shoot out like cannons. The teeth are each carved separately, not, as so often suggested, by a ribbed band of wood. In mask No. 11, although the hair treatment is similar to No. 16, all the curves and spheres that characterise the previous masks have disappeared; the brows, nose, eyes and ears are all based on rectangles. The mask is distinguished by a huge jutting mouth. Even the hole made to place the mask on the head is rectangular. There are deep-cut angular teeth.

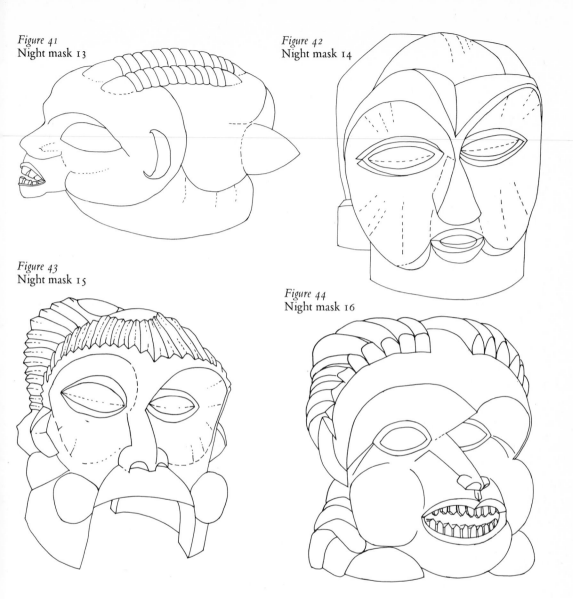

Figure 41
Night mask 13

Figure 42
Night mask 14

Figure 43
Night mask 15

Figure 44
Night mask 16

Night masks may be two- or four-faced. Masks Nos 12–15 and 17 are examples (and see also Plate 65). No. 12 (Plate 27) shows a Janus made to be worn on top of the head. The treatment of the face is typical of the abstract Night masks. It has mouths shooting out with a flash of teeth. The nose is insignificant and the brows are two arcs framing bulbous eyes, which are echoed in the spherical cheeks. The forehead is non-existent and slopes backwards into a crevice filled by the dual ruffs of a hairstyle or cap. No. 17 is another

139

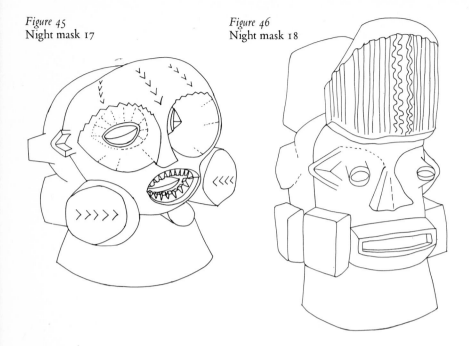

Figure 45
Night mask 17

Figure 46
Night mask 18

Janus. Here the curving brow is given cicatrisations. Deep, concave eye sockets have protruding eyes which catch the light as they emerge from the dark sur-round. There is an insignificant nose, a mouth with separated teeth, a protruding tongue. Under the chin is a small beard. The two faces in this mask are identical. Mask No. 15, another Janus, is interesting insofar as it appears to have been carved specifically to be carried on the shoulder rather than the head.

In these masks one feature may become distorted. In Mask No. 17 (Plate 62) the cheeks have been pushed to the side of the head; they have become units on their own, not even recognisable as cheeks by the Bangwa today. At first sight the two protuberances resemble hands except for the incised chevron pattern both here and on the forehead, which in the past, was a common facial scarification pattern. In a modern mask, No. 16 (Plate 21), carved in 1967, the cheeks have sunk to the bottom of the head; yet they still form an essential part of the whole. In No. 18 the square blocks are only recognisable as cheeks when compared with the other masks. This also applies to the oddly positioned ears and the fantastic treatment of cap and hair in Mask No. 7.

In some of the masks there is a concentration on the mouth (Nos 8, 9, 10, 11 are good examples). Whichever direction the mask is designed to face (to the sky when worn flat on the head or towards the viewers in a face mask) the mouth and teeth are given prominence. Grimacing mouths and bared teeth give

Figure 47
Night mask 19

strength to the terror masks. One of the pleasures enjoyed in the world of witches is eating human flesh; a chief, angry with a recalcitrant subject, may be heard to shout: 'I'll eat you!' Masks of these types (with exaggerated features), when seen alone, have been described as chimpanzees or apes. Comparing a series of such masks in this way, it is possible to see how the strange, sometimes grotesque faces derive always from a human model.

With such an analysis it is possible to guess the significance of the most abstract Night society masks. However distinct in conception the masks at each end of the benign-terrifying scale may appear to unfamiliar eyes, there is in fact a continuum between them when they are looked at in the context of the other Night masks. Mask No. 19 (Plate 66) can be seen now to have a bared mouth, cheeks pushed out from the plane of the face and a huge overhanging brow. The ribbing and fluting of other masks has been extended, so that hair and brows are amalgamated into one thin curving plane which rises up from the hemispherical cheeks. The ears have been relegated to an insignificant position. The mouth has developed into a curved mass of fluting to represent teeth with no horizontal division between the upper and lower teeth to complicate the line. The lips have all but vanished although they are clearly indicated at the sides. This mask had traces of a white chalky substance in the striations when it was found.

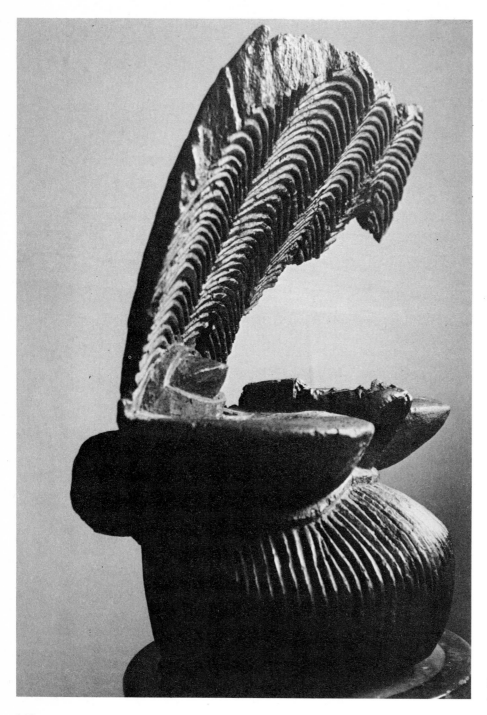

Plate 66
A broken Night mask

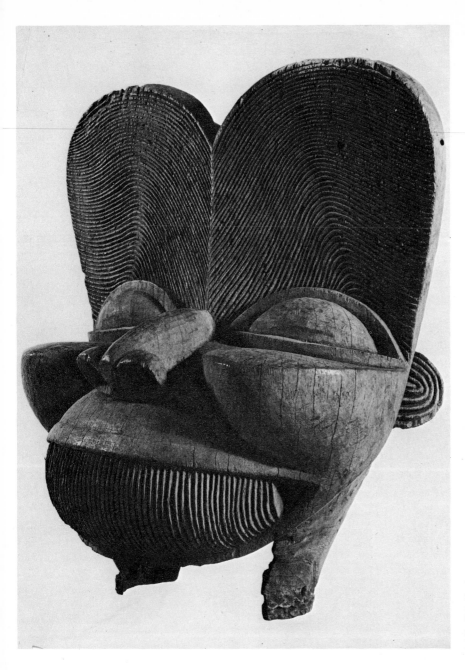

Plate 67
A mask found at
Bamenjo, East
Cameroon, but similar
to Bangwa Night mask
No. 19 (Plate 66)

Figure 47 is a reconstruction of this mask, which is unfortunately only a fragment (Plate 66). It is remarkably similar to four other famous published masks from the Bamileke region[1]; one is illustrated in Plate 67.

Four masks sharing a unique form have thus been found in the Western Bamileke region. If it is accepted that they are not the work of one sculptor it is probable that the carver of one must have had the opportunity of studying the works of the other two. Perhaps the masks were traded from one chiefdom to another. Some of the old sculptors were slaves, bought by wealthy chiefs from others at the height of their powers. Cases are known where famous sculptors were 'lent' by their masters. Whatever the answer, it seems clear that for the Bangwa and other subcultures of the Bamileke region it will be very difficult to establish distinct substyles, such was the mobility of sculptors and art objects in this area.

One thing is certain, however: that the Bangwa traders, who constantly experimented with new ideas and adapted new forms to their own socio-religious needs, have made – and to some extent still make – this small area of the Cameroon Highlands one of the most fertile breeding ground of sculpture in West Africa.

REFERENCES AND NOTES

INTRODUCTION
1. Conrau 1899.
2. Lecoq 1953.
3. See particularly Krieger 1960 and 1965.
4. See Krieger 1960 and 1965.

CHAPTER ONE
1. Tardits 1960.
2. Hurault 1962.

CHAPTER TWO
1. Fagg 1965: 66.

CHAPTER FOUR
1. See Fagg 1965.
2. Wingert 1965.
3. Krieger 1960, no. 33.

CHAPTER FIVE
1. See Harter, 1969.

BIBLIOGRAPHY

CONRAU, GUSTAV. Im Lande der Bangwa, *Kolonialblatt*, XII, 1899.

FAGG, WILLIAM. *Tribes and Forms in African Art*. London, 1965.

HARTER, PIERRE. Four Bamileke Masks, *Man*, 4, 3, 1969.
Le Lakam, stage initiatique des chefs bamilékés, *Bull. A.F.R.E.C.*, 4, 1969.
Arts plastiques de l'ouest Cameroun (in preparation).

HURAULT, JEAN. *La structure sociale des Bamilékés*. Paris, 1962.

KRIEGER, KURT. *Westafrikanische Masken*. Berlin, 1960.

KRIEGER, KURT. *Westafrikanische Plastik*, 1. Berlin, 1965.

LECOQ, R. *Les Bamilékés: une civilisation africaine*. Paris, 1953.

TARDITS, CLAUDE. *Les Bamiléké de l'Ouest Cameroun*. Paris, 1960.

WINGERT, PAUL. *Primitive Art*. Cleveland, 1965.

INDEX